D0926525

THIS SIGNED EDITION
HAS BEEN SPECIALLY BOUND BY THE PUBLISHER.

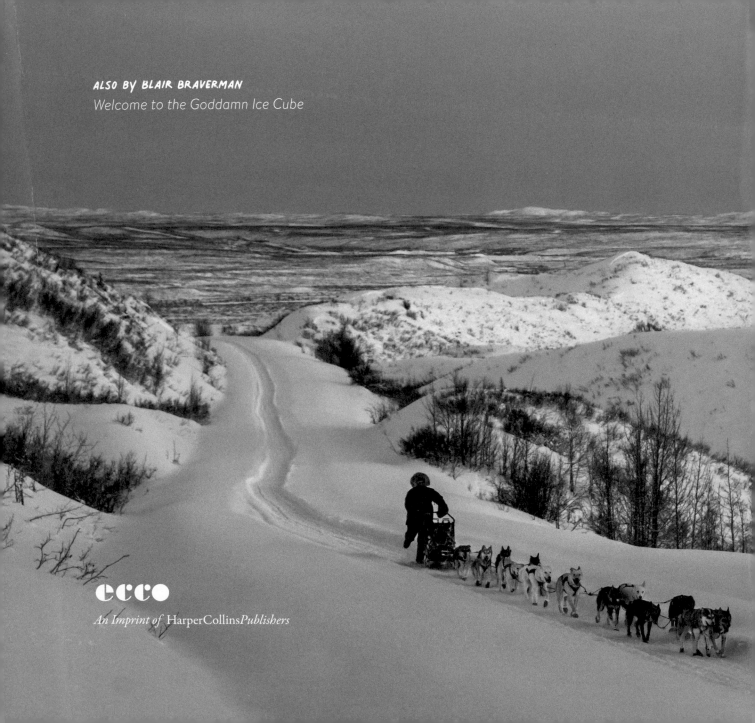

ALSO BY BLAIR BRAVERMAN

Welcome to the Goddamn Ice Cube

ecco

An Imprint of HarperCollins*Publishers*

DOGS
ON THE TRAIL

A YEAR IN THE LIFE

**BLAIR BRAVERMAN AND
QUINCE MOUNTAIN**

FOR THE #UGLYDOGS
AND THE NOT-SO-UGLY DOGS

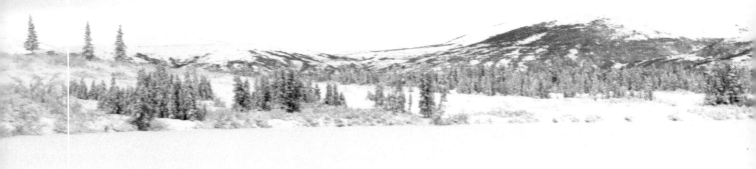

CONTENTS

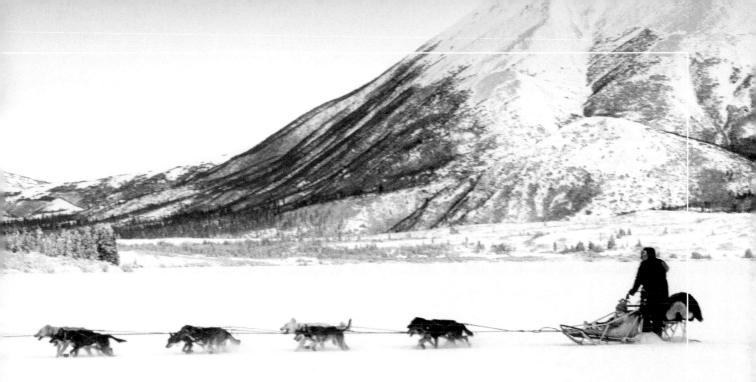

INTRODUCTION

Dogsledding has always lived through its stories.

The sport is mysterious. Mushers live in some of the coldest, most remote places in the world. They don't have neighbors; they spend more time with dogs than with people, and they like it that way. Even the most visible mushing events—long-distance races like the Yukon Quest and Iditarod—happen out of the public eye. Mushers and dogs head into the wilderness, then emerge days or weeks later. What happens out there? Only the team knows, but most of the team can't talk.

So it's up to mushers to tell their stories. We gather around campfires and wood stoves, warming our hands and recounting the trail. Stories about moose and ground blizzards, ice bridges and northern lights. Stories about every dog we ever loved.

He found me on the tundra.
She knew not to cross the river.
Never felt wind like that in my life.

As a kid in California, I got hooked on the stories. I lived in the dry, sweltering Central Valley, so the idea of cold alone—let alone a combination of cold and dogs—seemed like magic. I'd stare at photos of expeditions, malamutes, and wooden sledges, and wonder how it would feel to be surrounded by ice. I read Gary Paulsen and Farley Mowat, watched *Balto* and *Iron Will.* And when I was old enough, I moved to the Norwegian Arctic to learn to dogsled myself.

For a long time—as most people do, when they come to mushing—I helped with other people's dogs. I scooped poop, trained yearlings, and worked as a tour guide. I loved the sport, but figured I would always be stuck on the outskirts; as a freelance writer and journalist, my life didn't have the kind of stability that a dog team requires.

And then I met my now-husband, Quince Mountain, in grad school. He was a horse wrangler, a child of northern Wisconsin who lived in a hand-

hewn log house and had taught cold-weather survival. When we graduated, I moved to his homestead in the Northwoods. All of a sudden, I was rooted—and in a cold place, no less. It was the kind of life where I *could* have sled dogs. Quince wasn't a musher, but he was game.

We adopted our first six dogs in 2014, a small team for exploring the winter woods. A year later, we took over a team of fifteen dogs from a musher who was retiring, and it wasn't long before Quince was as hooked as I was.

Pretty soon our whole life was dogs. I woke up planning what I'd make for their breakfast; I fell asleep imagining where we would run next. There were hours, days even, when nothing existed but the shifting sled runners, the gentle puffs of breath. It was the only world that mattered.

All I wanted to talk about, think about, was the dogs. (All any musher wants to talk about is their dogs.) So I started sharing pictures of them on Twitter, little anecdotes. It felt self-indulgent, like pulling photos from my wallet and showing them to anyone who was too polite to back away. I figured people could just ignore me.

But to my astonishment, an online community started to form around the team. These were people who loved animals and nature, who appreciated stories. The most moving part of it all, to me, was how they came to know and love the dogs—Hari and

Jenga, Grinch and Jeff and Flame. Loved them and drew strength from them, just like we did.

Fans of the team started calling themselves the Ugly Dogs, after someone told me to *Go back to your ugly dogs*—and as Quince says, the Ugly Dogs are the salt of the earth. They support each other through tough times, volunteer at events, send mail to one another, and raise funds for community organizations along the trails where we race. Every day, it's a gift to be part of the community that's formed around the team.

It's given us a chance to share mushing, this mysterious lifestyle, with people who might not otherwise encounter it. We spend a lot of time answering questions: Why do the dogs look like that? What do they eat? Do they get cold? What happens when they retire? And sometimes those questions (which we've also addressed in this book) lead us to new questions, ones I'm still trying to figure out. What does it do to your heart to work so closely with animals? How does it change your relationship to nature, to life on earth?

My goal has always been to share mushing as it is, not just the beauty and wagging tails but the hard parts, too. The sport has challenges that are, in their way, romantic: storms and wolves, the bone-deep chill that comes with sleeping out in forty below. Even sleep deprivation and hallucinations can be points of pride.

But mushing also means facing difficulties that are banal, uncomfortable, and sometimes sad. On a run

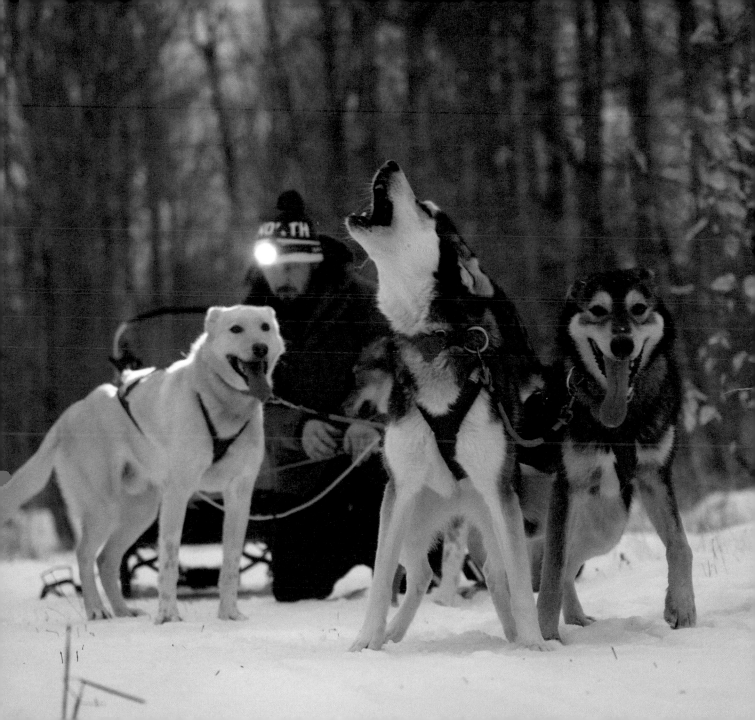

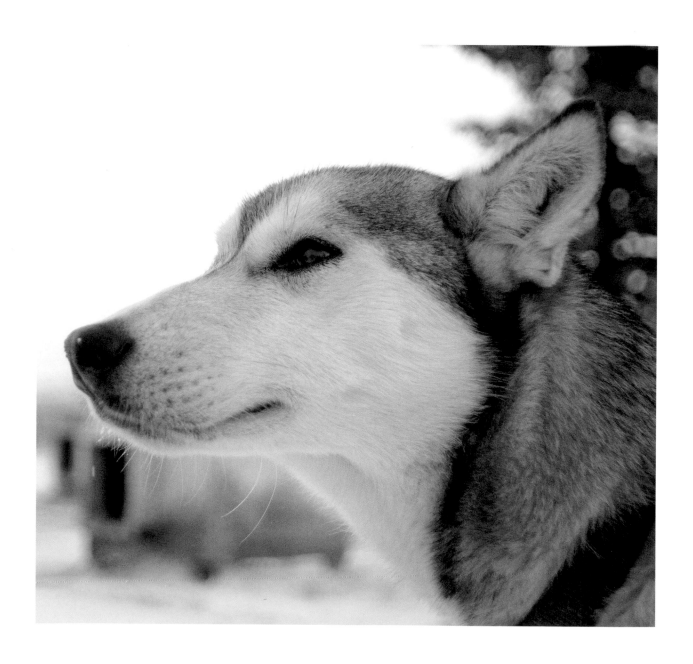

in 2018, while crossing Devil Track Lake in Minnesota, one of our dogs attacked and almost killed another dog, Boudica. I couldn't break up the fight. Finally, terrified, I threw myself over Boudica and shielded her with my body. As horrible as it was, it felt important to share that story, too. I didn't want to paint a facade over a real and complicated lifestyle; I wanted, have always wanted, to share reality. In part, this felt like a responsibility. If someone decided to start mushing after hearing my stories, it was only fair to them—and more important, to their dogs—to give a clear idea of what they were committing to.

The truth is that mushing is both very exotic and not exotic at all. If you've ever had a dog pull you on a bicycle, or while you run, that's a kind of mushing. And if you've ever thrown a tennis ball for a retriever, again and again, then you have an idea of the bottomless enthusiasm that a sled dog brings to the trail.

Sled dogs aren't half-wild, as some suppose. They're *dogs*, with all the courage and sensitivity of dogs, the curiosity and excitement and longing to be loved. They're also unique, both physically and mentally; they're adapted to cold, have an unceasing drive to run, and have the rare athleticism to see that through. They can be very happy living as pets, as long as their significant exercise needs are met; they can be very happy living outdoors with their team; and many of them, even most, will enjoy both of these lifestyles over the years.

If anything, they've taught *me* to be half-wild: to build a life outdoors, following instincts, trusting my teammates. They've taught me that wilderness isn't a place to visit, but a home to return to. They've taught me that there is far less difference between humans and animals than I thought.

One of the first essays I ever loved was Annie Dillard's "Living Like Weasels." She describes a weasel's skull latched to an eagle, still biting, long after the weasel itself died and the rest of its body fell away. And she writes:

> *I think it would be well, and proper, and obedient, and pure, to grasp your one necessity and not let it go, to dangle from it limp wherever it takes you. Then even death, where you're going no matter how you live, cannot you part . . .*

I don't want to live like weasels; I have too many necessities. But I do want to live like sled dogs. I want to travel through life with a team that has my back. I want to explore new places, but get just as excited about familiar ones. I want to find comfort in routine and opportunity in change.

What does it mean to live like sled dogs—for the dogs, for me, maybe even for you? This book is the start of an answer.

—BLAIR

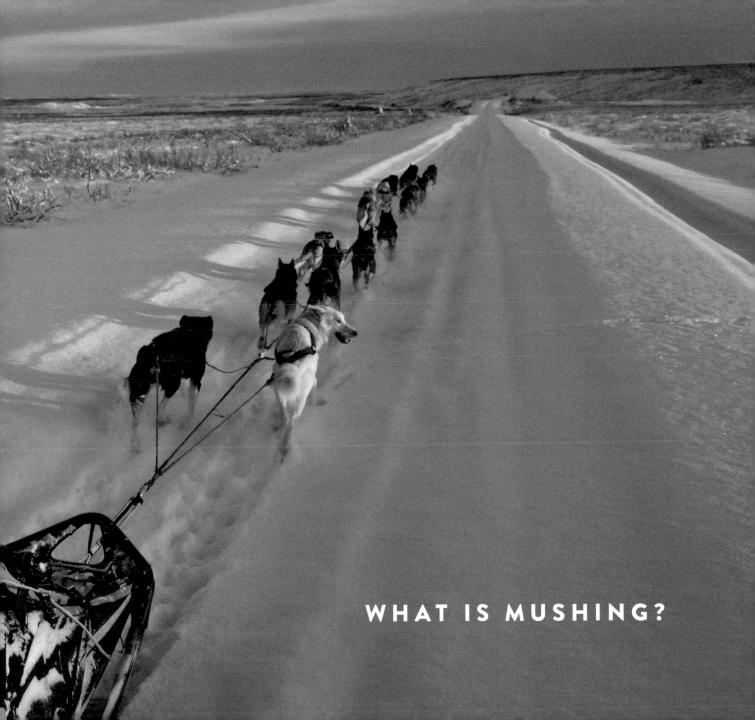

WHAT IS MUSHING?

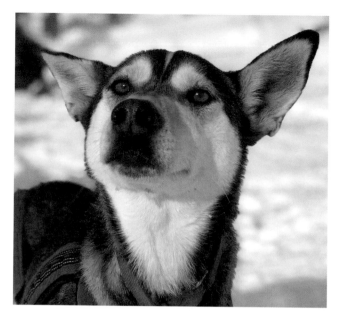
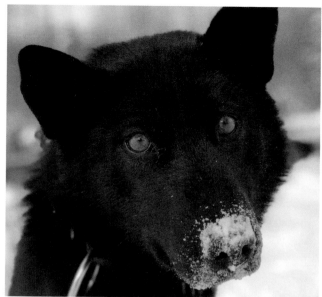
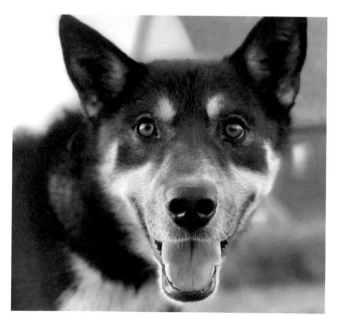

ALASKAN HUSKIES

"But I thought sled dogs were huskies!"

We get this comment again and again. Most people have only seen sled dogs in movies, so they're surprised to see that our dogs come in every color and a handful of shapes. In fact, our sled dogs *are* huskies—but "husky" is an umbrella term for northern-breed dogs with instincts to pull. Gorgeous Siberian huskies—the huskies most people picture when they think of sled dogs—are only one variety.

Our dogs are Alaskan huskies, which is the most common type of sled dog outside Russia and Greenland. Alaskan huskies aren't an official breed. They're a heritage, an amalgamation of northern-type dogs who are highly efficient athletes, descended from Alaskan village dogs, Qimmiqs (Canadian Inuit dogs), Greenland dogs, and anything else that made a case to get mixed in. Because they've been bred for performance, not looks, Alaskans can have floppy or pointy ears, blue or brown eyes, and can range in size from thirty-odd to seventy-odd pounds. They can be a solid color, multiple colors, speckled, or have striking masks.

But something interesting happens when you look closer. In DNA tests, this motley group of dogs is *more* genetically distinct than many other breeds. It's just that much of their similarity is on the inside—in their cold-weather adaptations and unique metabolisms—rather than just in their appearance.

SO WHAT SETS ALASKAN HUSKIES APART?

1. COLD-WEATHER ADAPTATIONS

Alaskan huskies might look like mutts, but they're exquisitely well-suited to the cold. Their toes are webbed, making natural snowshoes, and they have thick, fatty paw pads to protect their feet from chilly ground. They have double coats, with an outer layer of fur that shields against the elements and a dense inner layer that traps heat. If you see sled dogs napping on a snowy day, you'll notice that snowflakes don't melt on them; their floof is designed to keep cold out and warmth in.

2. METABOLISM

Sled dogs' metabolisms are unique among mammals: they rely less on glycogen and are able to burn fat from their food super efficiently. It's common to see researchers at sled dog races, taking vitals and collecting samples as they try to solve the mystery of how sled dogs are so good at what they do.

3. DRIVE TO PULL

Sled dogs are obsessed with running. They know instinctively how to run and pull, and they're wild about it. That's also what makes the sport so addicting for humans: glide through the woods with a pack of huskies who are absolutely flipping their lids with excitement, and the joy is contagious. Just like them, you'll never want to stop.

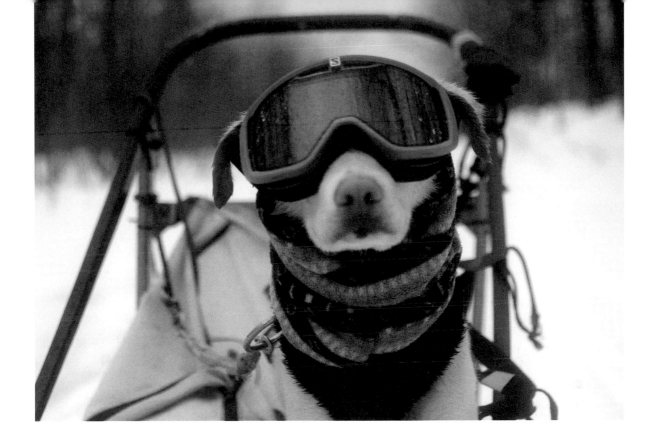

NO SNOW, NO PROBLEM

If you go to a sprint event—a short, fast dogsled race—you may see sled dogs who aren't huskies at all. German shorthair pointers often love pulling, for instance, and so do many other breeds, who may be better adapted to heat than huskies are. Wherever you live in the world, whatever your climate, odds are good that there are mushers near you. And since there are some forms of mushing, like bikejoring and scooterjoring (see page 40), that only involve one or two dogs, they can be great options for urban folks or families with pets.

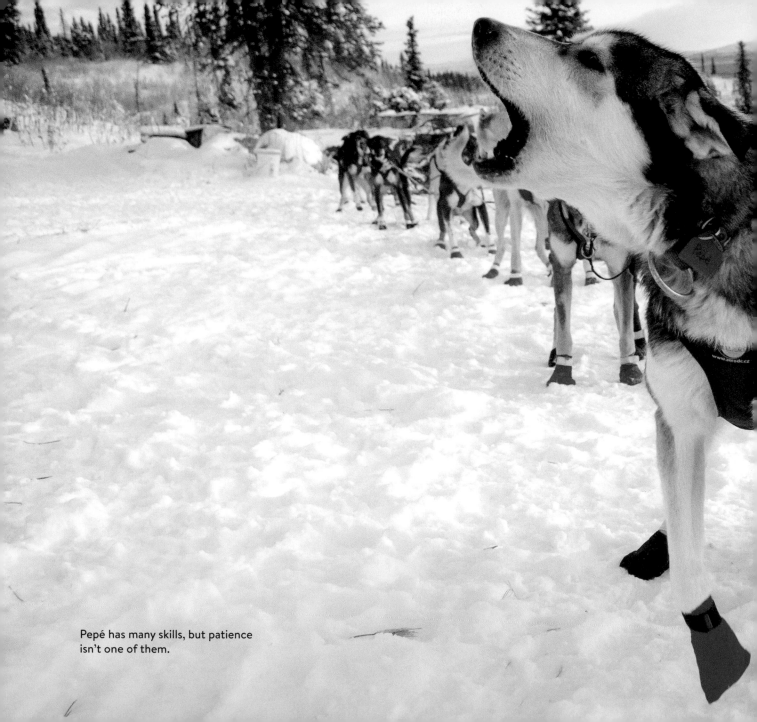

Pepé has many skills, but patience isn't one of them.

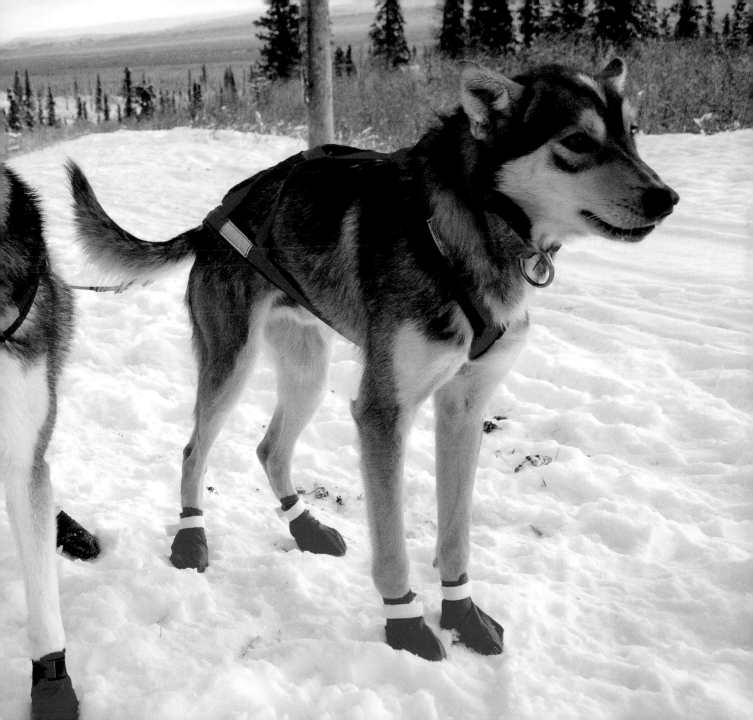

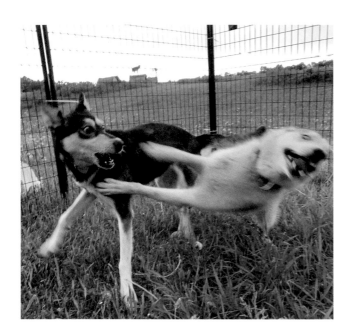

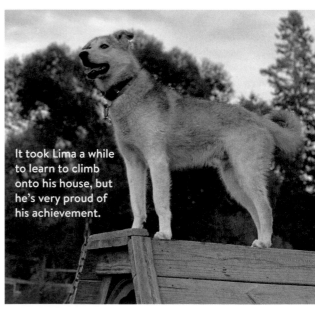

It took Lima a while to learn to climb onto his house, but he's very proud of his achievement.

WHY DO SLED DOGS LIVE OUTSIDE?

Living (mostly) outside is important for sled dogs, because it keeps them acclimated to changing seasons, just like it does for wild canines like wolves and coyotes. In the fall, as days get shorter and cooler, dogs build up far thicker coats than they would if they lived indoors, and those coats keep them warm and comfortable through the winter.

Most sled dogs live in a dog yard, where their houses are separated with pens or tethers. Our dogs know their own houses, and trot back to them after a run or play session. Tethers let the dogs play with their neighbors safely while keeping the security of their own personal space, and make it easy for mushers and handlers to move freely to cuddle, offer food and water, and keep things clean. Pens offer cozy companionship and snuggle time.

We plan activities for our dogs year-round, especially in the warmer months, when they're not running in harness as much. Many of our dogs can play loose on the homestead, but for those who are apt to roam—or for times when we're not right there to supervise—we have several fenced-in areas where groups of dogs can play together safely. It's always fun to bring in surprises—like new balls, climbing structures, and toys—for them to explore.

But our dogs' favorite play areas, by far, are the meadows, rivers, and forests that surround our home.

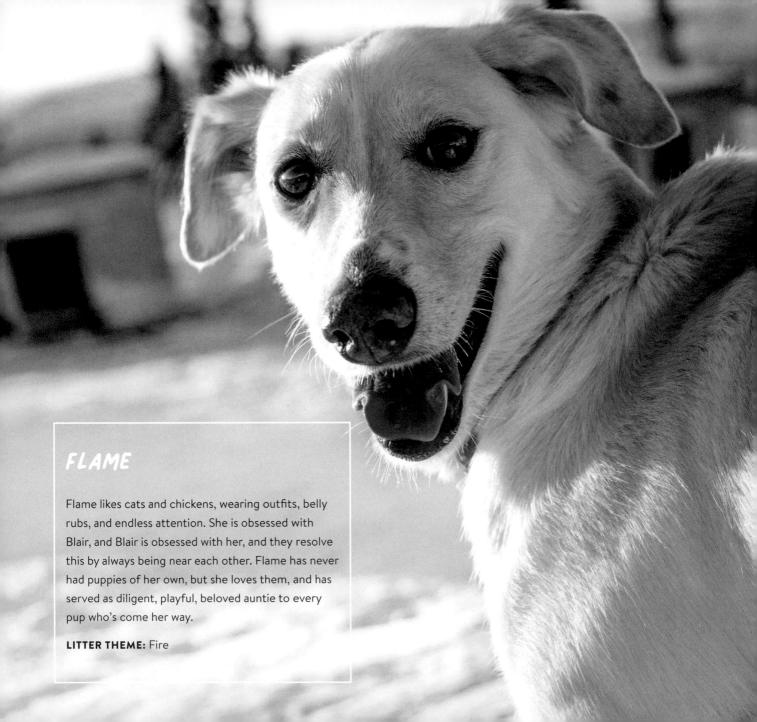

FLAME

Flame likes cats and chickens, wearing outfits, belly rubs, and endless attention. She is obsessed with Blair, and Blair is obsessed with her, and they resolve this by always being near each other. Flame has never had puppies of her own, but she loves them, and has served as diligent, playful, beloved auntie to every pup who's come her way.

LITTER THEME: Fire

We're lucky to live in the Northwoods, where our dogs have plenty of space to explore off-leash.

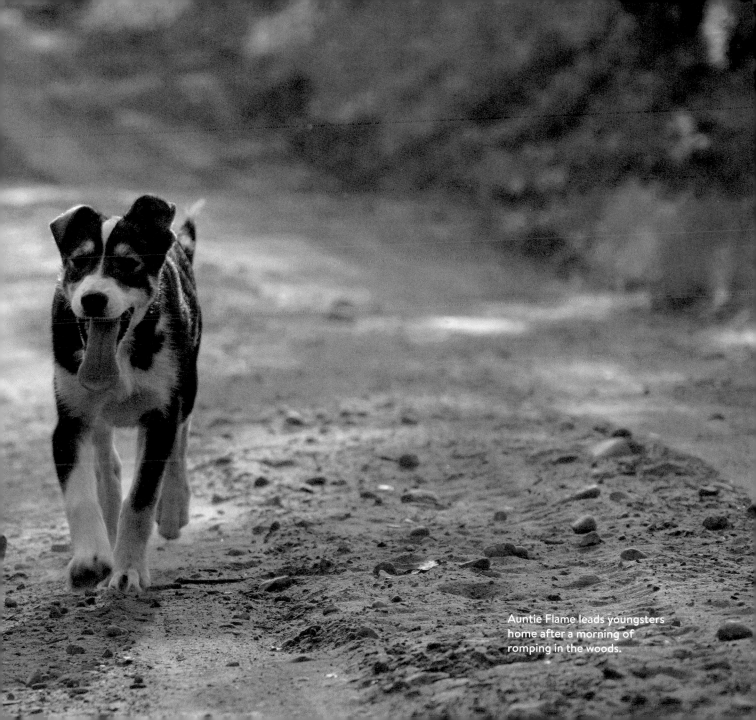

Auntie Flame leads youngsters home after a morning of romping in the woods.

ROLES ON THE TEAM

WHEEL DOGS

Wheel dogs help the team make smooth turns. A strong and inspired wheel dog can learn to take turns wide, helping their musher dodge trees and other obstacles. They are also tough-minded and easygoing, unbothered by the rumbling or swishing of the rig "chasing" right behind them.

 Many dogs are well-suited to multiple positions, and move around the team as need and conditions allow. Spike, for instance, runs beautifully in wheel with Colbert—and he also makes a clear-headed co-leader for his mama, Pepé.

TEAM DOGS

Team dogs are power, the motor of a team. Which is another way of saying that while the position does not come with unique responsibilities, it's every bit as important as the others.

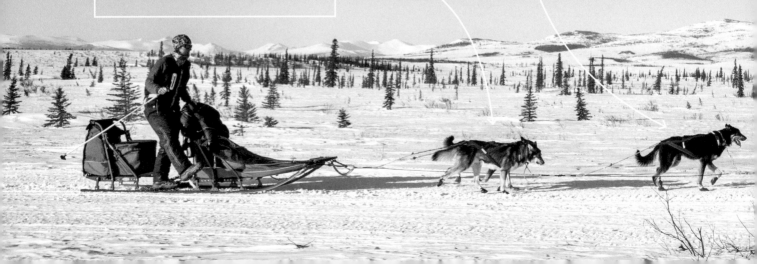

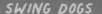

SWING DOGS

Swing dogs hold the towline taut, taking pressure off the leaders so that they can focus on decision-making and setting the pace. Swing is also a good position for young dogs to learn the ropes of leading.

LEAD DOGS

Lead dogs are responsible for navigating obstacles, setting the pace, and staying alert to their musher's cues. It's a high-pressure position, and it takes a bold, motivated dog with a strong sense of confidence and self. In situations when the trail is buried in with snow, a lead dog may also *break trail*, finding the safest path and pushing through powder so the rest of the team can follow.

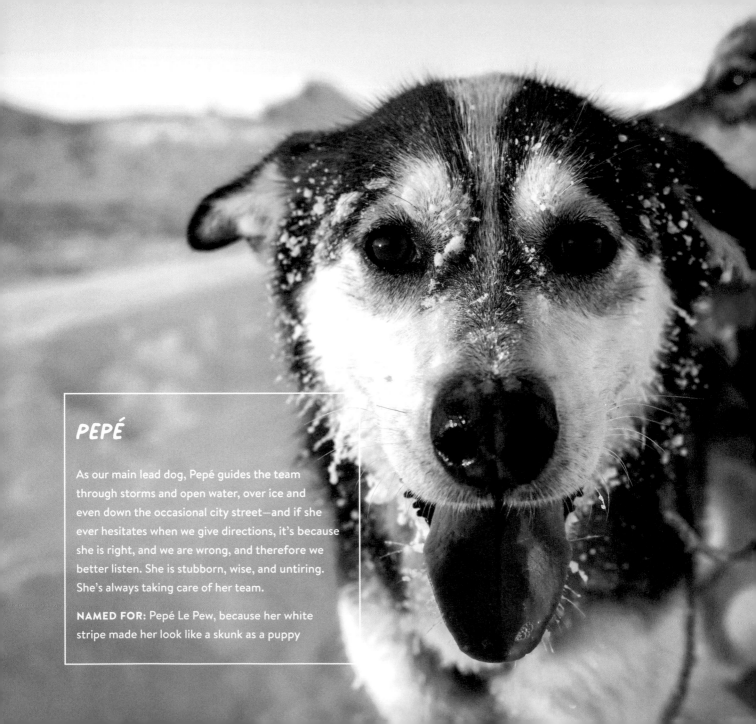

PEPÉ

As our main lead dog, Pepé guides the team through storms and open water, over ice and even down the occasional city street—and if she ever hesitates when we give directions, it's because she is right, and we are wrong, and therefore we better listen. She is stubborn, wise, and untiring. She's always taking care of her team.

NAMED FOR: Pepé Le Pew, because her white stripe made her look like a skunk as a puppy

HISTORY

Traveling by dog team feels so simple that we can forget that the practice is ancient. Sled dogs were first bred in Siberia, almost ten thousand years ago—and were buried in human graves, suggesting that the bond between dog and musher goes just as far back. They crossed the Bering Strait; they played a key role in cultures across North America, Scandinavia, Greenland, and Siberia. Until recently, if you wanted something transported in the North, sled dogs were the way to do it.

Sled dogs are famous for the 1925 Serum Run, when a dog-team relay carried diphtheria antitoxin to the village of Nome, Alaska, but the event was less unusual than folks outside Alaska might assume.

Those dog teams and their mushers, who were mostly Indigenous, were already part of a network that carried mail, news, fur, and other supplies throughout the Alaskan interior.

Long-distance dogsled racing was developed in the 1960s and 1970s to honor and preserve the tradition of mushing, and to save sled dogs from near-extinction. Today, sled-dog sports range from canicross and bikejoring—with a single dog pulling a human runner or biker—to thousand-mile expeditions. Our little team—with all its races and adventures—is just a tiny part of a tradition that's nearly as expansive as the history of the North itself.

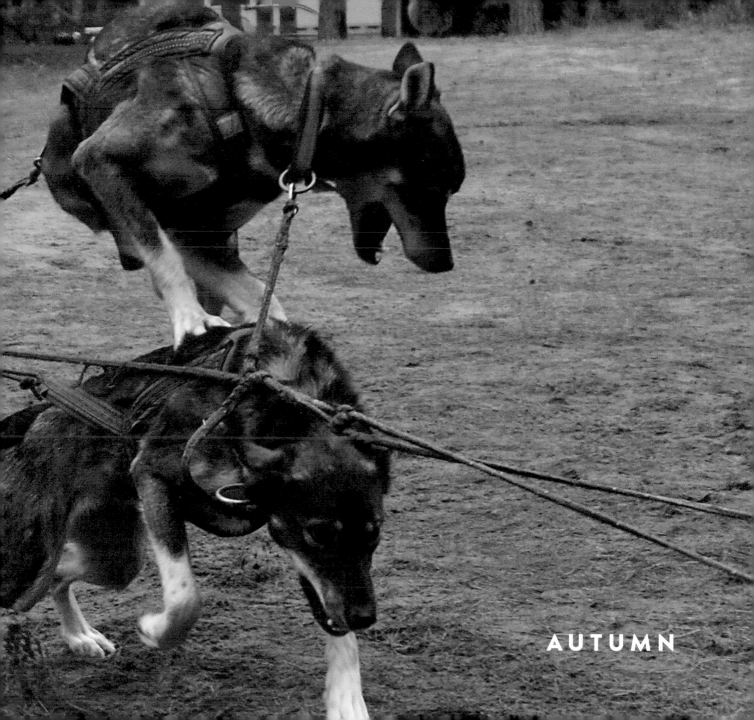
AUTUMN

THE CRANBERRY BOG

Years ago, Quince remembered a lake he used to visit as a teenager. The shore was made up of floating islands of vegetation, which drifted around by the day, leaving the land in a slightly different configuration every time you went there. If you brought a paddle, you could ride one of the islands around like a little boat. His friends called it Changing Lake.

We found the lake at the end of an unmarked dirt road. It turned out to be a cranberry bog, and the floating islands were masses of cranberry bushes. Sometimes when you stood on them, half-sinking, wild cranberries floated to the surface; and the water wasn't boggy, but it had a warm smell, like old leaves.

Over the years, visitors had left planks and pallets to walk on, making a maze of bridges and platforms, a playground of textures and smells.

Of course, we had to bring the dogs there. The dogs were suspicious at first: the ground looked solid, but it bounced, and was apt to flip over beneath them. But they came to love the bog—it was always new, always wild. A puppy who was scared to cross a bridge one day might scamper over it the next; and though some of the dogs were hesitant about liquid water, preferring the frozen stuff, they quickly learned how fun it could be. Pretty soon it was their favorite place to play.

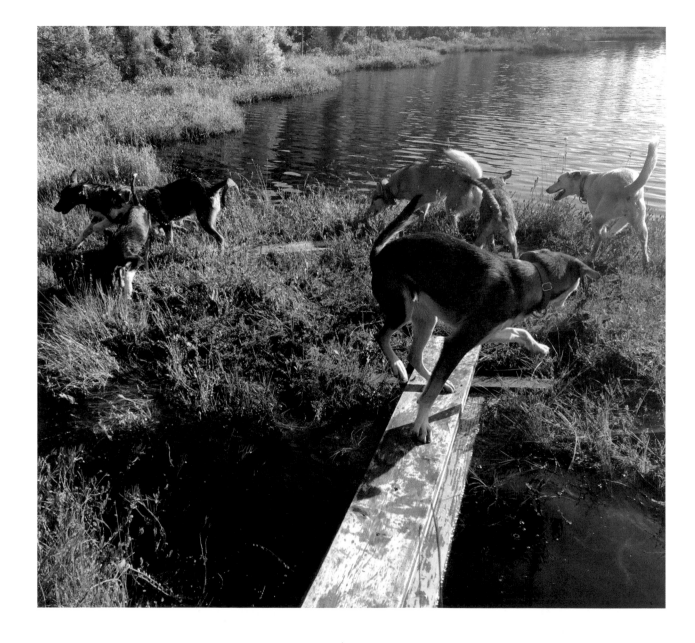

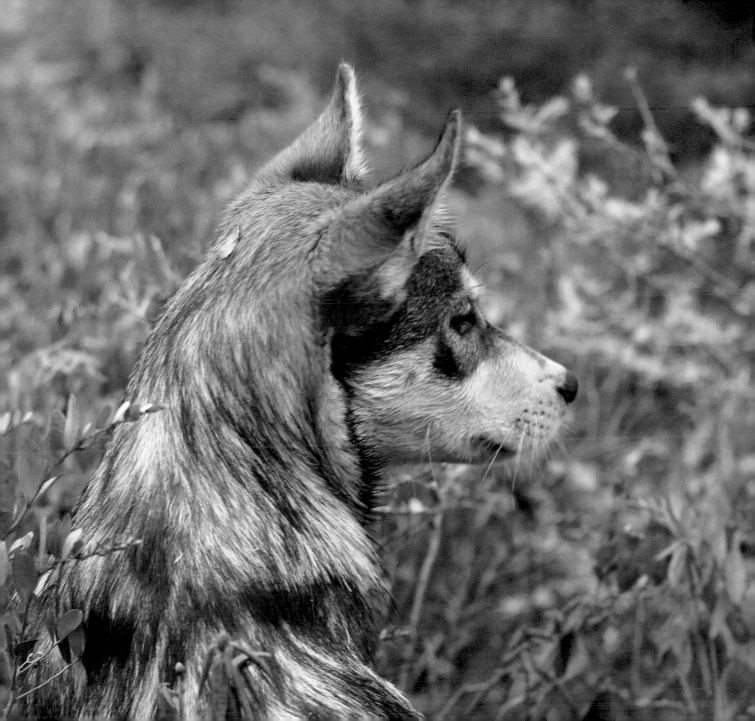

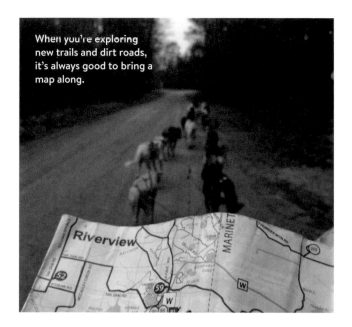

When you're exploring new trails and dirt roads, it's always good to bring a map along.

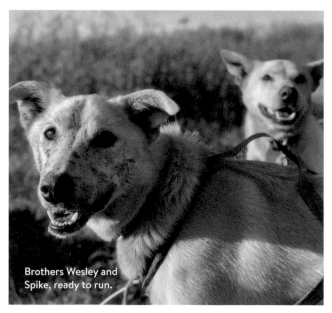

Brothers Wesley and Spike, ready to run.

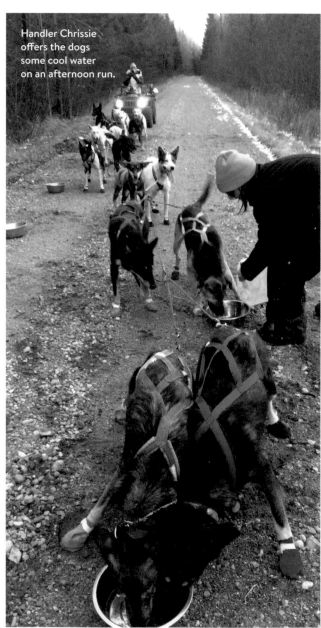

Handler Chrissie offers the dogs some cool water on an afternoon run.

HARNESS UP!

When the temperature dips below 50 degrees, it's cool enough for the dogs to run in harness. In our corner of northern Wisconsin, that usually means September. We'll watch the weather reports for weeks, impatient and excited, then wake before dawn and harness the dogs by headlamp. Pepé scouts the trail, Grinch howls, and we're off into the darkness. The dogs know exactly what to do. Just like us, they've been waiting.

It's damp, usually. Everything wet with dew, and the dogs' breath rises in clouds, glowing in the first beams of sunlight. We run three miles, stopping every few minutes for water breaks. We're home in twenty-five minutes. By eight in the morning, we humans are drinking coffee and the dogs have gone back to sleep.

After a week or so, we jump to five miles. Then eight or ten, depending on weather and how the dogs are feeling.

We're in no rush. We focus on building consistency and strength. Because early fall runs are so short—at least compared to thirty and forty-mile runs later in the winter—we often make several in a day, running the dogs in small groups or even individually. It's a good time to work with young leaders, giving them a chance to face open trail without the pressure of big-team social dynamics.

WHAT ARE THEY PULLING?

Dogs will pull anything that's not anchored down—and before snow falls, that usually means wheeled carts, ATVs, and other dryland rigs. Mushers tend to have strong preferences about their rigs. We often mush with scooters and carts for smaller jaunts, and use an ATV when we're running many dogs together.

BIKES

An off-road bike is great for speed training, or working with a single dog, because the musher can add power by pedaling along—but since there's no easy dismount, bikes can make for some spectacular wipeouts.

SCOOTERS

Blair's favorite dryland rig is a scooter. The musher keeps a low center of gravity and has the option of kicking with one foot or jogging up hills, just like with a sled. There aren't many companies that make off-road scooters, so we got ours from a guy who fabricated it with spare bike parts in his garage near Green Bay.

CARTS

Here (top right) Quince tests out a three-wheel cart at a dryland race. Pepé and Clem are leading, with Spike and Colbert in wheel. A strong team with a light rig like this reaches speeds over twenty-five miles per hour.

ATVS

For most distance mushers, the go-to dryland rig is an ATV, either with or without an engine. A good-sized ATV is heavy enough, and has enough braking power, to easily handle a team of eight to fourteen dogs. It can also be used for free-running, with the dogs running loose ahead of it.

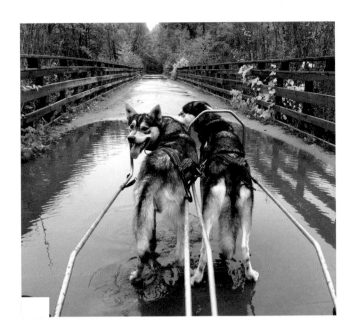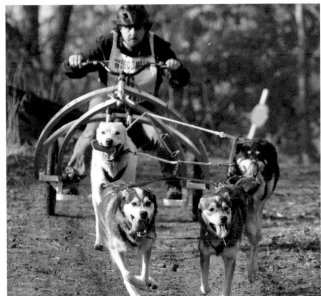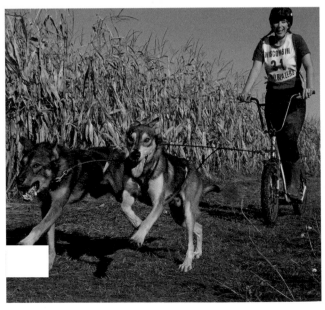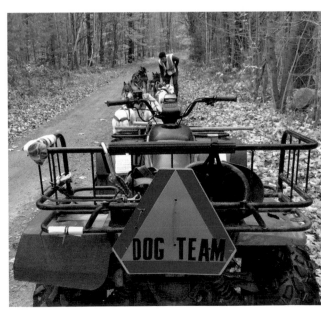

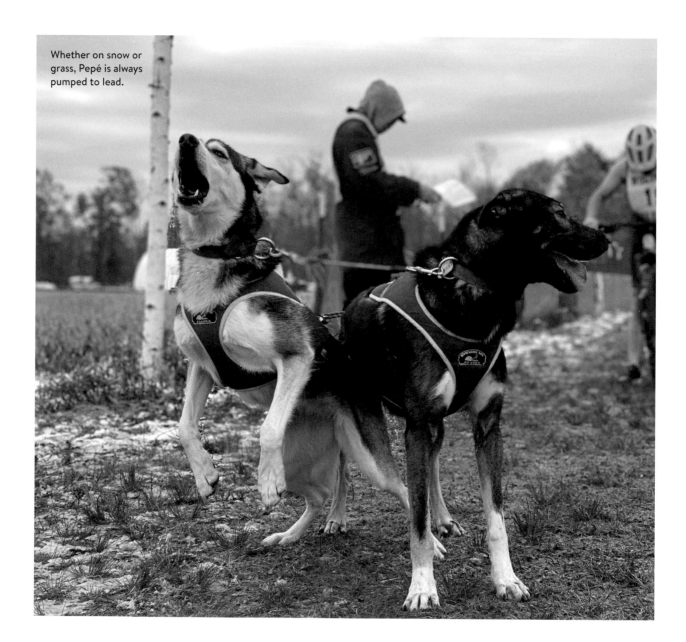

Whether on snow or grass, Pepé is always pumped to lead.

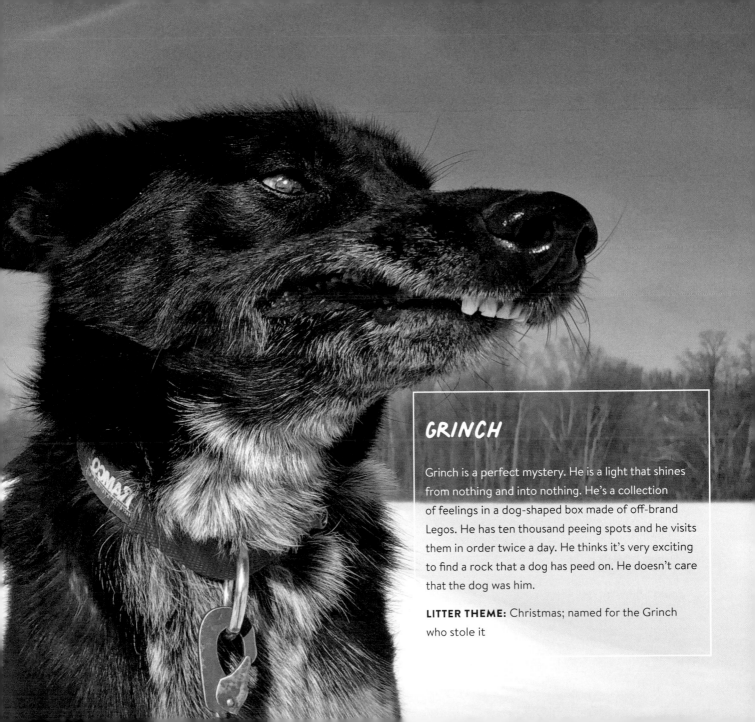

GRINCH

Grinch is a perfect mystery. He is a light that shines from nothing and into nothing. He's a collection of feelings in a dog-shaped box made of off-brand Legos. He has ten thousand peeing spots and he visits them in order twice a day. He thinks it's very exciting to find a rock that a dog has peed on. He doesn't care that the dog was him.

LITTER THEME: Christmas; named for the Grinch who stole it

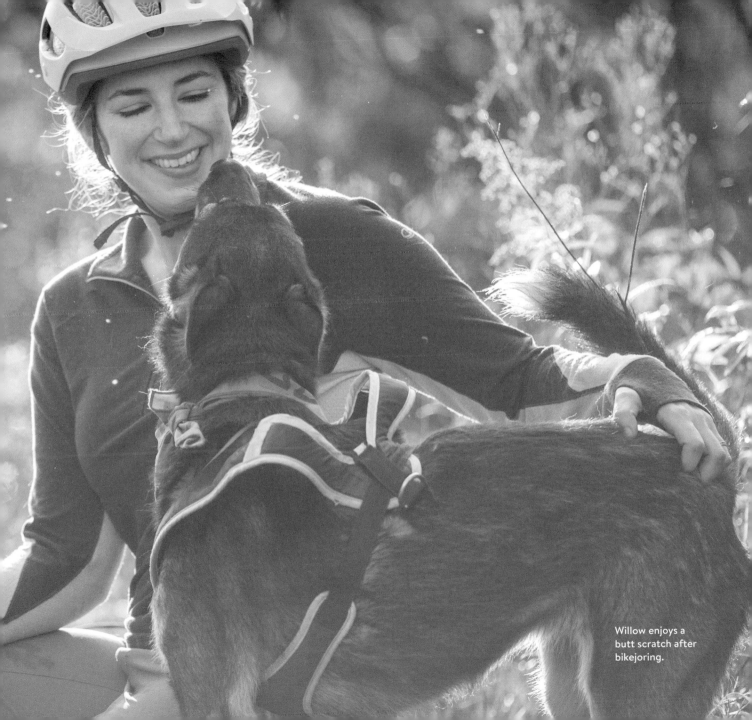

Willow enjoys a
butt scratch after
bikejoring.

MUSHER CAMPOUTS

In the fall, dog teams come from hours around to train together in the woods. Campouts are a chance to bond with the community after a long summer—humans catch up on the latest news, dogs reunite with their siblings and old friends, and everyone celebrates the fact that winter is on its way. These gatherings can also mark a return to musher time, that familiar, disorienting existence when sleep and running happen at intervals throughout the day and night, and you're as likely to be mushing at midnight as to be asleep at noon.

From a training perspective, group campouts offer two main benefits for the dogs. Since mushers are often far-flung, it can be unusual for sled dogs to encounter other teams on the trail. Mushers plan for their teams to meet on the trail as much as possible, which is *very exciting* for the dogs. They practice side-by-side passing, head-on passing, and navigating by scent. Back at camp, all the teams howl together as one.

The other benefit is subtler. Dogs, like humans, can catch "colds" when they're in groups, and a big meetup allows them to share germs with each other early in the year. A lot of mushers believe that exposing their dogs to other teams in the fall keeps them healthier throughout the season.

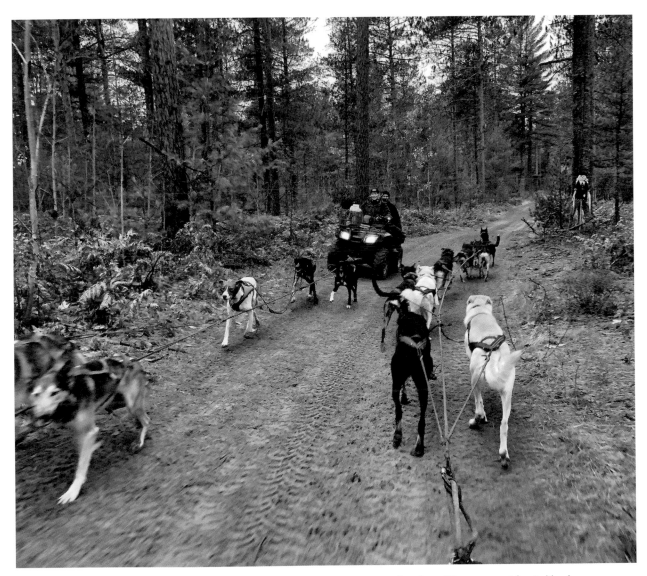

A beautiful head-on pass. On the right, you can see a scarecrow in a tree. The campout host, Monica, decorated her home trails for Halloween—a fun way to get the dogs used to strange distractions. If they ever encounter a scarecrow in the wilderness, they'll be set.

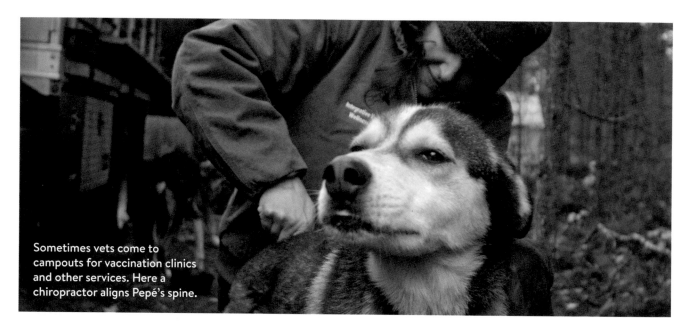

Sometimes vets come to campouts for vaccination clinics and other services. Here a chiropractor aligns Pepé's spine.

Just try going anywhere alone at a campout.

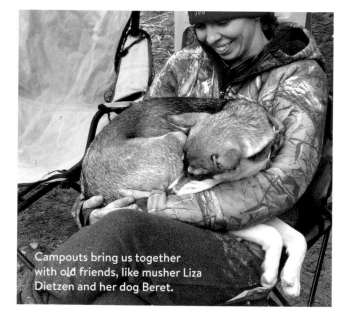

Campouts bring us together with old friends, like musher Liza Dietzen and her dog Beret.

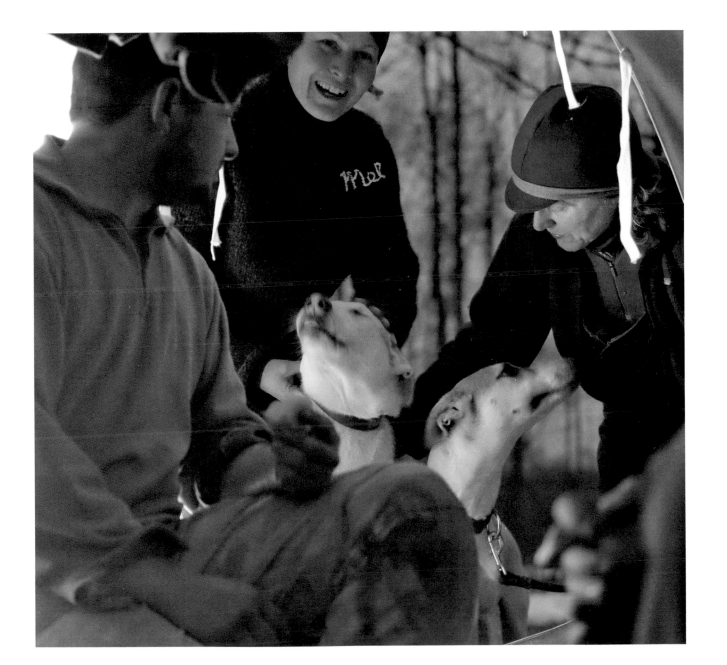

TIME TO EAT

A fifty-pound sled dog can burn more than ten thousand calories a day, which is like a medium-sized human burning sixty-three Big Macs. So as you can imagine, mushers think about dog food *a lot*.

Luckily, Alaskan huskies thrive on a high-fat diet. Our dogs get most of their calories from raw meat and high-performance kibble, plus fatty foods like chicken skin and bear fat. We buy meat in fifty-pound blocks, then use a saw to cut it into snack-sized chunks. On warm days, the dogs like munching frozen meat, and on cold mornings we thaw it in water to make a hot stew.

Sled dog diets vary by region. Some teams in Alaska eat salmon or sheefish as a staple, whereas our team relies heavily on venison and bear scraps from our local Northwoods butcher and taxidermist. The dogs are happy to eat parts of the animal that people don't, so they make sure nothing goes to waste.

Some of our dogs' favorite foods include:

VENISON: We live in an area with a lot of subsistence deer hunting, and people bring us scrapings (and occasional roadkill), so venison is a staple for our dogs all fall and winter.

BEEF: A classic. We feed ground beef with different fat content for different temperatures—higher fat for cold days, lower fat for warm days—because when the dogs are warm, they lose their appetite for fat. They also like hamburger patties.

PORK: We've never met a sled dog who doesn't love pork. It was the only meat Willow would eat during her pregnancy, and we often buy the dogs pork chops for special occasions.

HOT DOGS: Hot dogs are junk food, so we save them for treats.

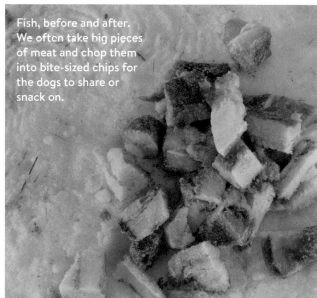

Fish, before and after. We often take big pieces of meat and chop them into bite-sized chips for the dogs to share or snack on.

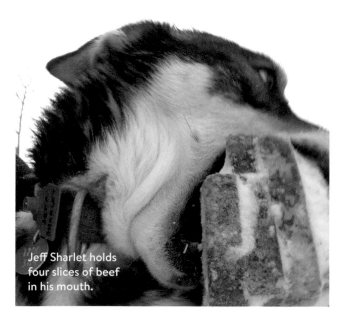

Jeff Sharlet holds four slices of beef in his mouth.

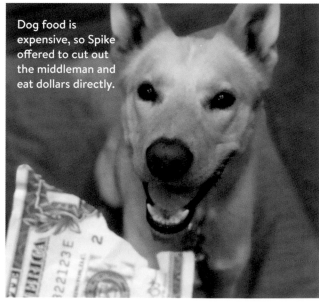

Dog food is expensive, so Spike offered to cut out the middleman and eat dollars directly.

BEAR FAT: We get a few hundred pounds of bear fat from the taxidermist every fall. Bear fat makes the dogs smell like bears, but their fur gets super-soft, and they think it's delicious.

UNSALTED BUTTER: Always good to have on hand. Available at gas stations!

CHICKEN: Chicken is probably the dogs' favorite snack while they're running; we give each of them a raw frozen chicken thigh every hour or so. Chicken provides fast energy, so it's a good boost before long climbs and other challenges. Plus, it's easy to find in every grocery store.

CHICKEN SKIN: Like beef, we buy this in blocks and cut it into small cubes, which are easy to pass out as snacks. Everybody loves chicken skin.

BACON: Sometimes we add bacon to stews for extra flavor.

SALMON OIL: We wish our dogs liked salmon oil more, because it is very good for them. We sneak it into their food when we can.

FISH: Fish is controversial. The dogs have to be in the right mood for it. But it's great in summer, or for warm days on the trail, because it has a high water content.

STEAMED BONE MEAL: Our dogs chew lots of bones at home, but we add bone meal to their food when we're on the road so they get plenty of calcium.

BEAVER: Every now and then, somebody brings us a beaver. Beaver meat is rich and nutritious, and was traditionally considered one of the best foods for sled dogs.

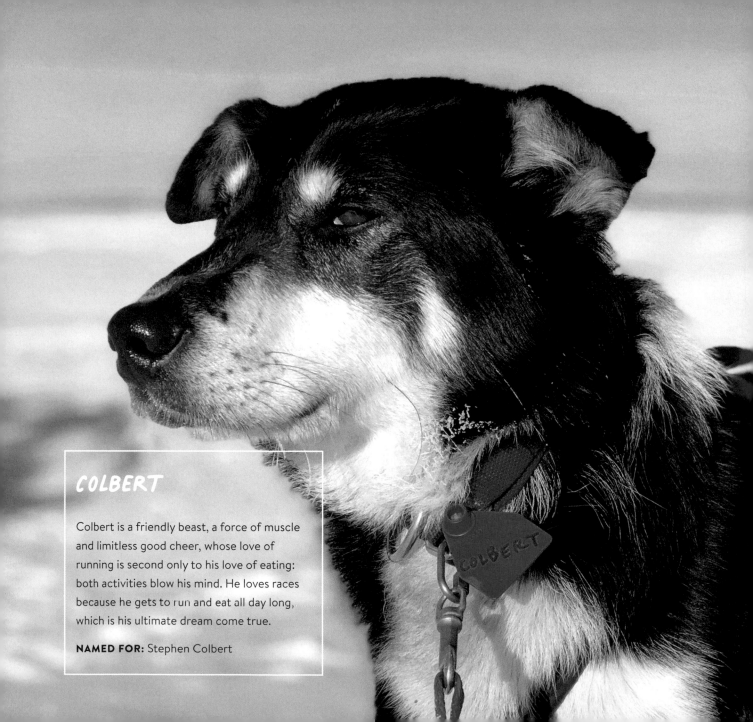

COLBERT

Colbert is a friendly beast, a force of muscle and limitless good cheer, whose love of running is second only to his love of eating: both activities blow his mind. He loves races because he gets to run and eat all day long, which is his ultimate dream come true.

NAMED FOR: Stephen Colbert

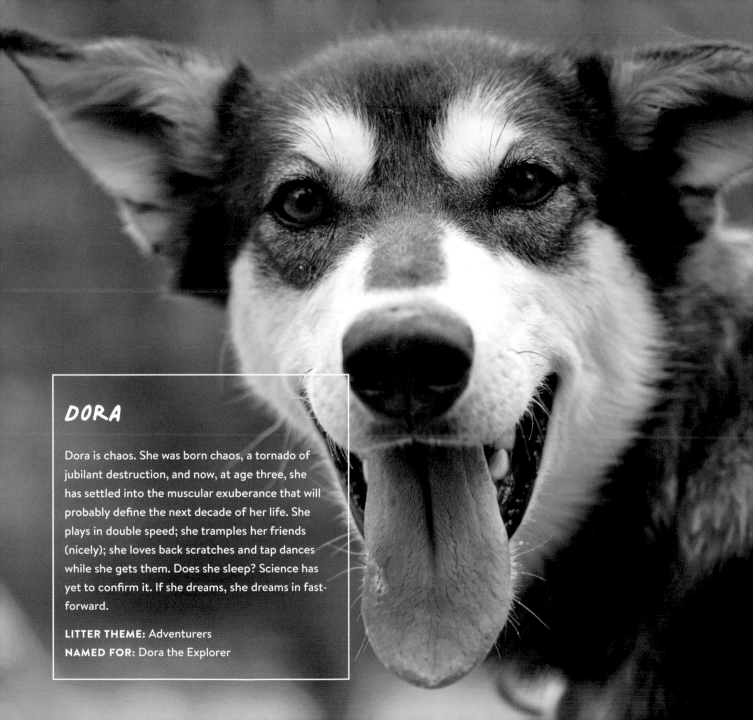

DORA

Dora is chaos. She was born chaos, a tornado of jubilant destruction, and now, at age three, she has settled into the muscular exuberance that will probably define the next decade of her life. She plays in double speed; she tramples her friends (nicely); she loves back scratches and tap dances while she gets them. Does she sleep? Science has yet to confirm it. If she dreams, she dreams in fast-forward.

LITTER THEME: Adventurers
NAMED FOR: Dora the Explorer

THE INTERNATIONAL DOG BUS

Sled dogs like truck rides.

The truck takes them interesting places, but our dogs seem to like riding for its own sake, too, and are always eager to climb aboard. Truck rides mean new smells, frequent treats, and a different way to see the world go by.

We call our truck the Dog Bus. It has twenty different boxes, and the dogs can ride single or double depending on the temperature, how big they are, and if they like to cuddle en route. In the winter, the boxes are bedded with straw, which keeps the dogs warm, and in the summer they're lightly bedded with wood shavings, which stay cooler. The dogs can get very attached to their individual boxes. Pepé likes top left, and Flame always takes the middle.

Road trips with sled dogs are an adventure in their own right—but we've driven the team to Alaska and back enough times that we've got the system down. The dogs get out to eat, drink, use the bathroom, and stretch their legs every few hours. Whenever we can, we look for big, open places, set back from the highway, where they can run off some of their energy. The farther north you drive, the easier it is to find places like that.

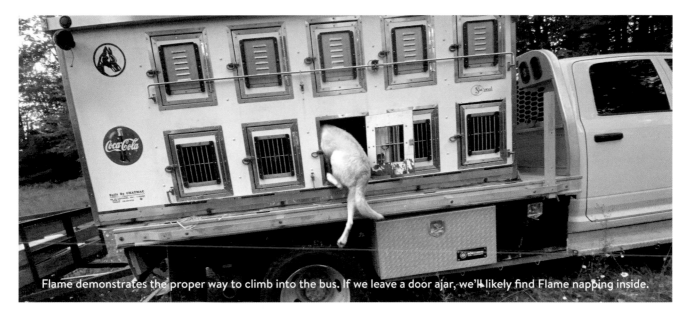

Flame demonstrates the proper way to climb into the bus. If we leave a door ajar, we'll likely find Flame napping inside.

We also have a trailer with bunks for the dogs. It's vented, but it has less airflow than the truck, so we only use it in cooler weather. Here's Flame in her bunk, before and after she sees snacks coming.

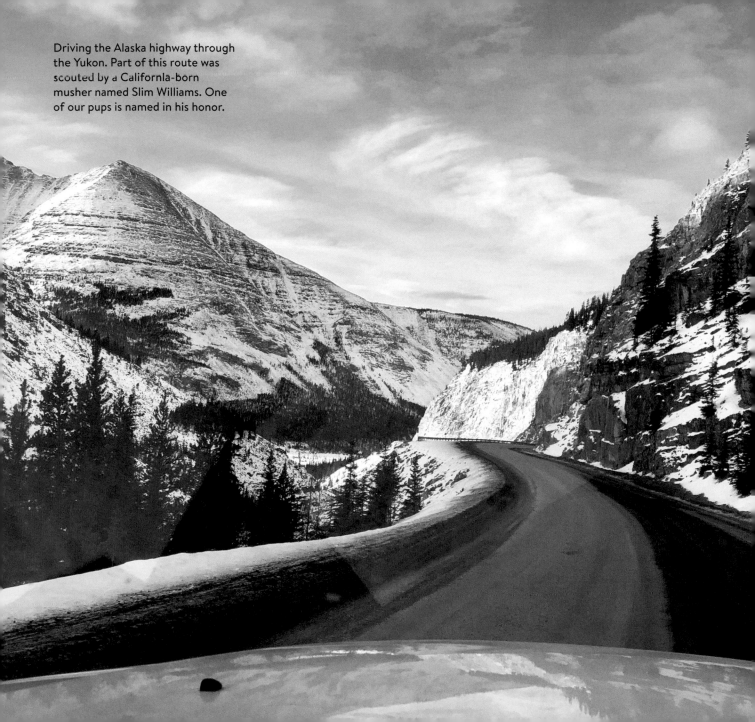

Driving the Alaska highway through the Yukon. Part of this route was scouted by a California-born musher named Slim Williams. One of our pups is named in his honor.

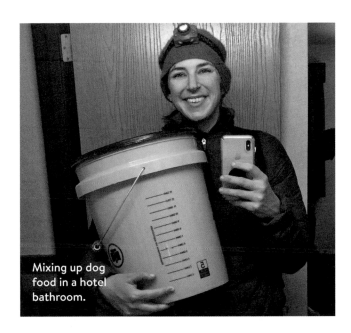

Mixing up dog food in a hotel bathroom.

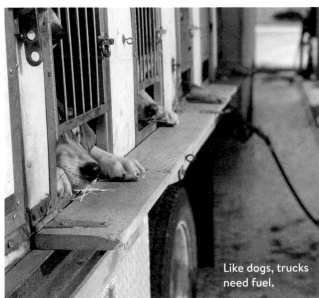

Like dogs, trucks need fuel.

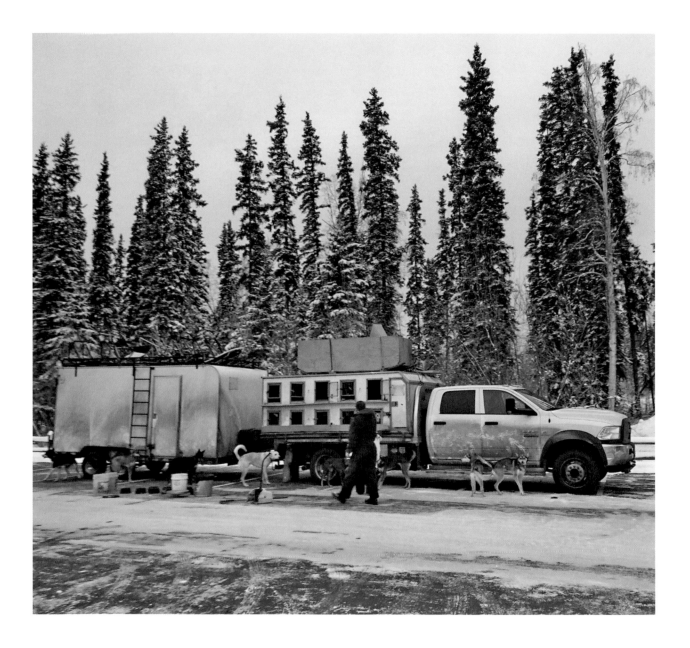

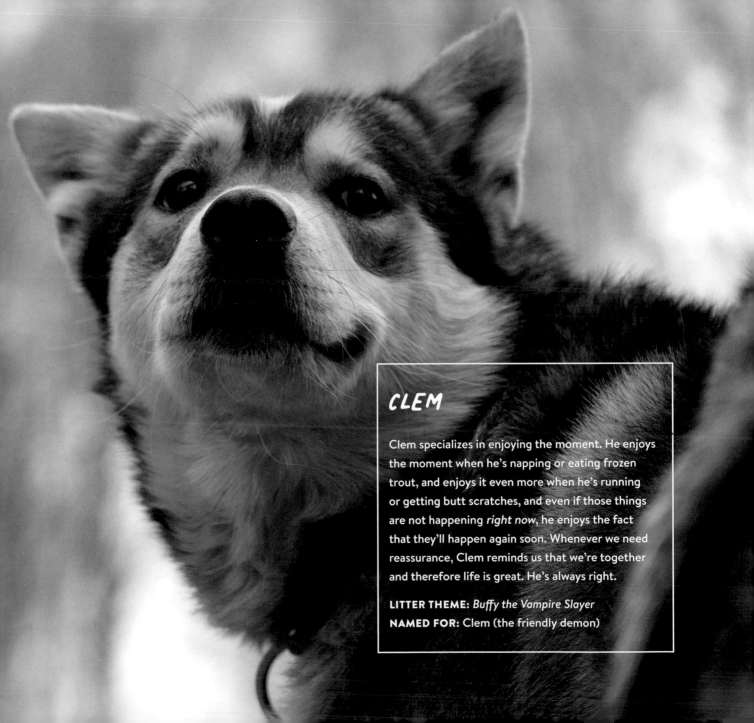

CLEM

Clem specializes in enjoying the moment. He enjoys the moment when he's napping or eating frozen trout, and enjoys it even more when he's running or getting butt scratches, and even if those things are not happening *right now*, he enjoys the fact that they'll happen again soon. Whenever we need reassurance, Clem reminds us that we're together and therefore life is great. He's always right.

LITTER THEME: *Buffy the Vampire Slayer*
NAMED FOR: Clem (the friendly demon)

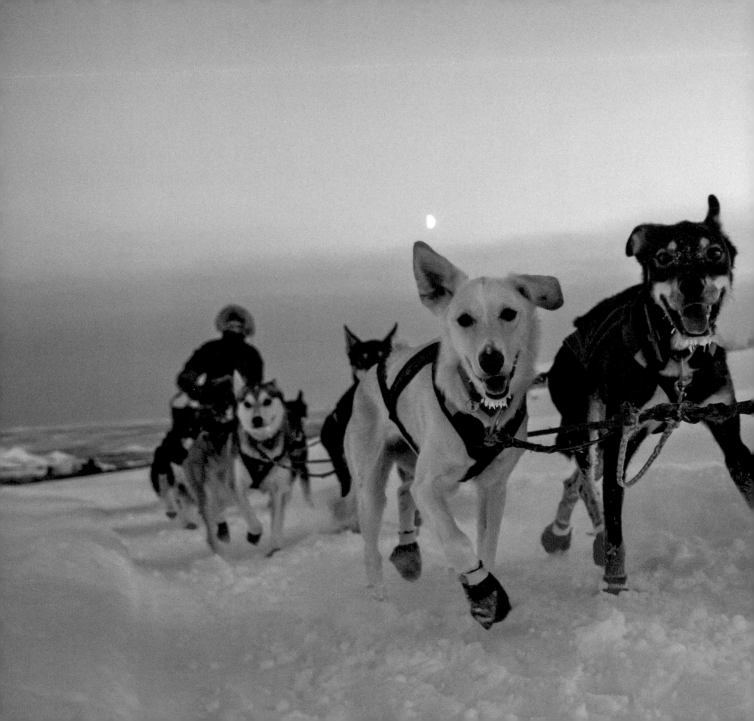

WINTER

CONDITIONING

As winter ramps up, so does the dogs' conditioning. In typical trail conditions, our dogs run about ten and a half miles per hour, which means that a day's run might take two to five hours, and longer if we make several stops along the trail. We try to keep our runs varied, so they're always interesting—the dogs encounter fast trails and deep snow, daylight and moonlight. They love checking out new scenery, and they get excited about coming back to their home trails, too.

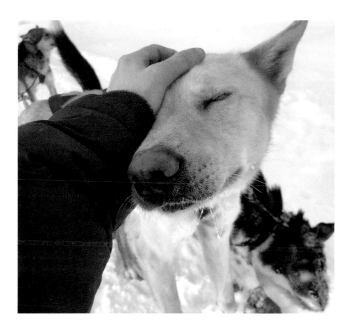

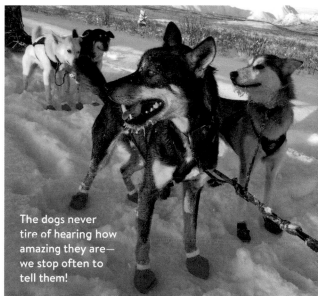

The dogs never tire of hearing how amazing they are— we stop often to tell them!

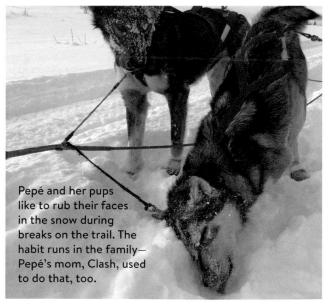

Pepé and her pups like to rub their faces in the snow during breaks on the trail. The habit runs in the family— Pepé's mom, Clash, used to do that, too.

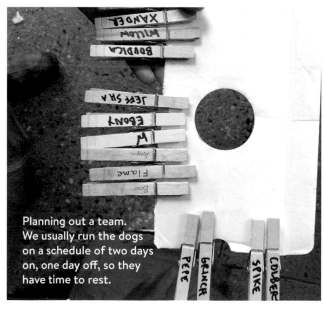

XANDER
WILLOW
BOUDICA
JEFF SHA
EBONY
FLAME
Boo
PEPE
BRINGR
SPIKE
COLBER

Planning out a team. We usually run the dogs on a schedule of two days on, one day off, so they have time to rest.

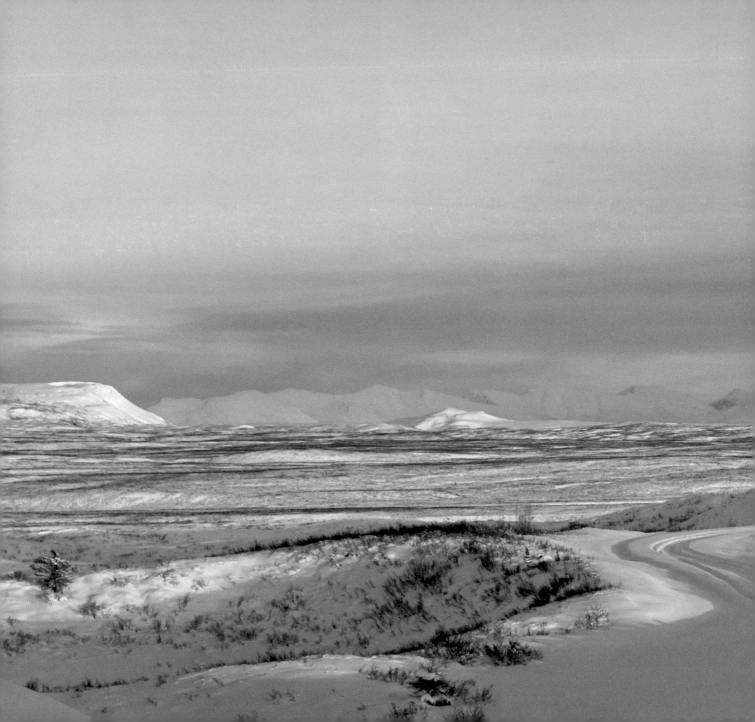

DENALI HIGHWAY

Highway is a misleading term. Picture a 135-mile stretch of road in Alaska that's left unplowed all winter. As soon as snow falls, it becomes a mushing paradise. Teams come from all around to run on the wide, smooth trail, covering anywhere from a few dozen to hundreds of miles on a trip. When we train in Alaska, it's often on the Denali Highway; and we spent one winter living and training at a bush lodge along the trail. The lodge was sixty miles from the nearest plowed road, and only accessible in the winter by snowmobile and dog team.

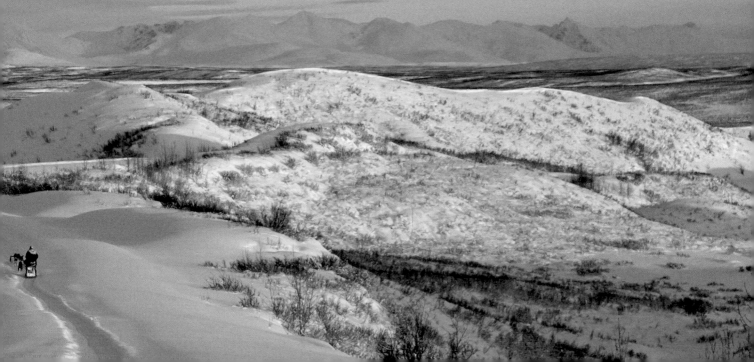

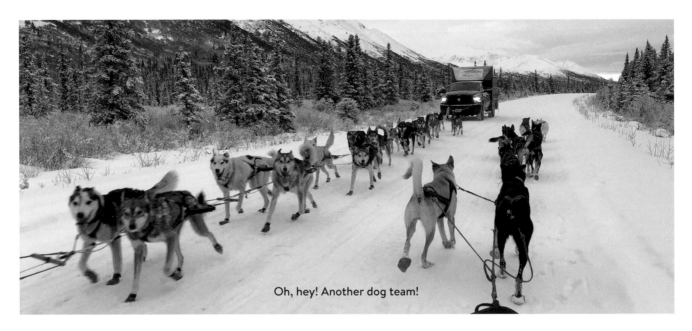

Oh, hey! Another dog team!

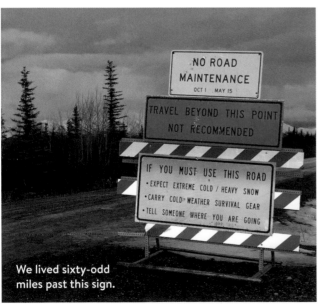

We lived sixty-odd miles past this sign.

NO ROAD MAINTENANCE

OCT 1 MAY 15

TRAVEL BEYOND THIS POINT NOT RECOMMENDED

IF YOU MUST USE THIS ROAD
• EXPECT EXTREME COLD / HEAVY SNOW
• CARRY COLD-WEATHER SURVIVAL GEAR
• TELL SOMEONE WHERE YOU ARE GOING

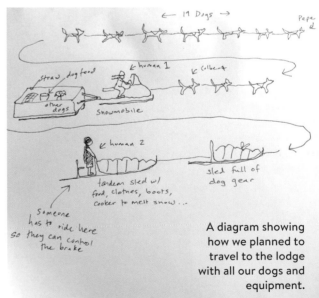

← 14 Dogs →

Pepe

straw dogfood
other dogs
← human 1
← Colbert
Snowmobile

← human 2
tandem sled w/ food, clothes, boots, cooker to melt snow...
sled full of dog gear

Someone has to ride here so they can control the brake

A diagram showing how we planned to travel to the lodge with all our dogs and equipment.

Well-traveled pizzas.

Sorting booties after a long day.

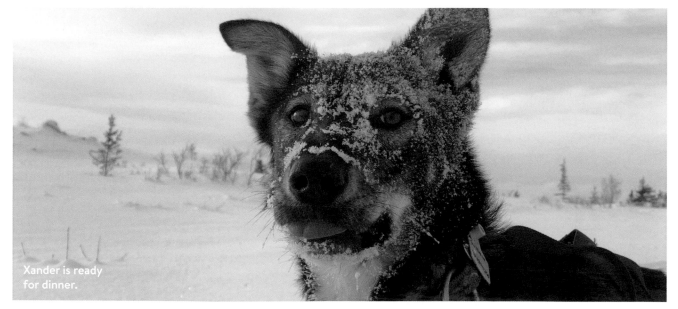

Xander is ready for dinner.

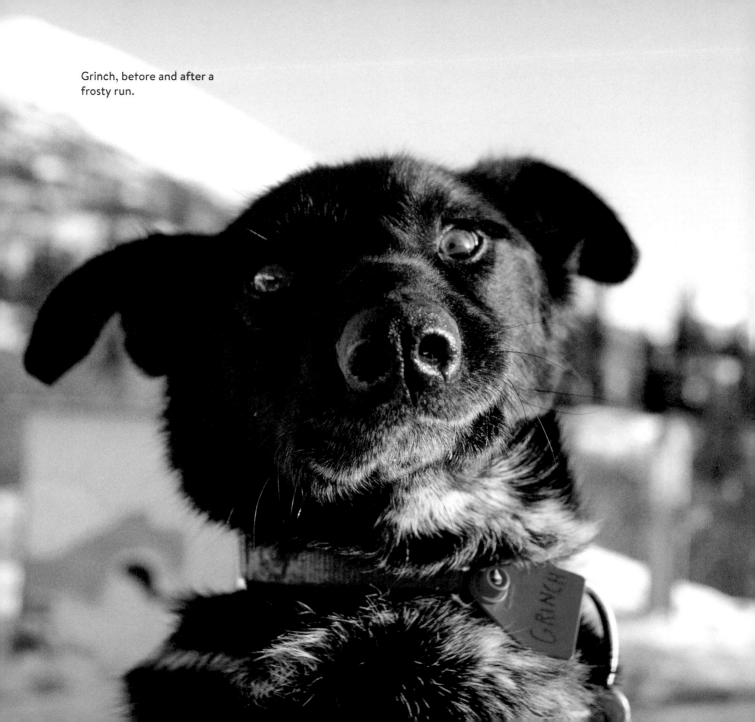

Grinch, before and after a
frosty run.

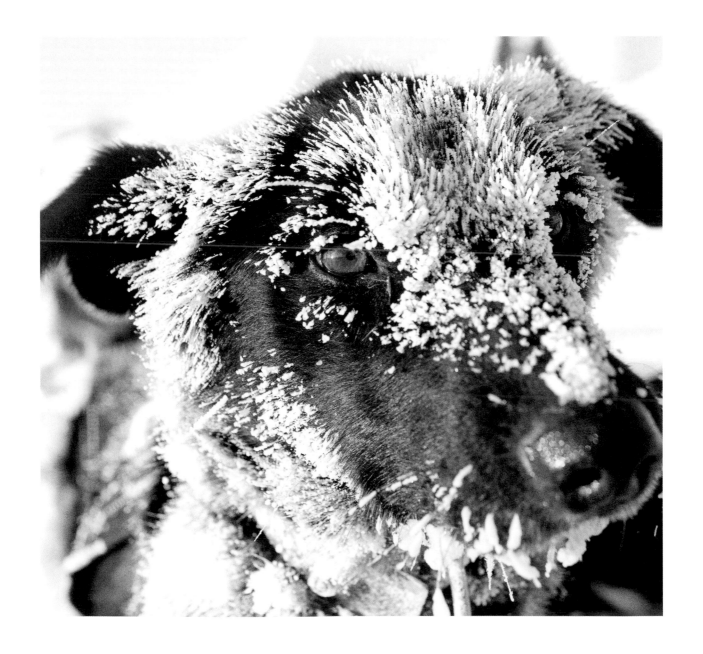

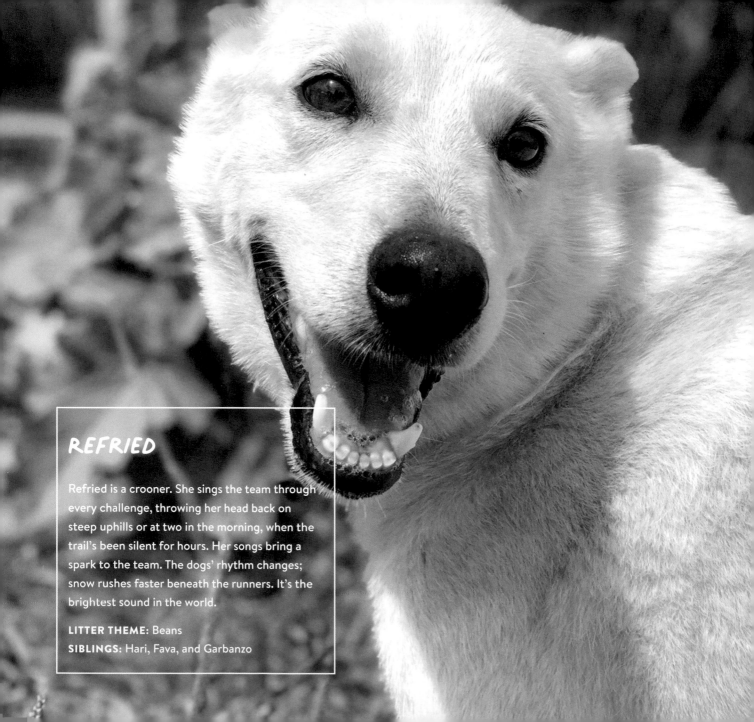

REFRIED

Refried is a crooner. She sings the team through
every challenge, throwing her head back on
steep uphills or at two in the morning, when the
trail's been silent for hours. Her songs bring a
spark to the team. The dogs' rhythm changes;
snow rushes faster beneath the runners. It's the
brightest sound in the world.

LITTER THEME: Beans
SIBLINGS: Hari, Fava, and Garbanzo

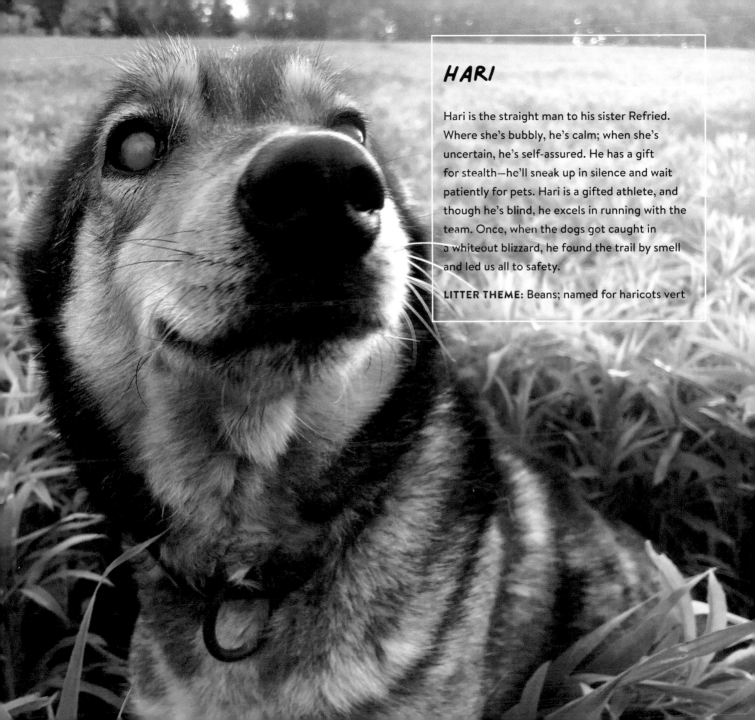

HARI

Hari is the straight man to his sister Refried. Where she's bubbly, he's calm; when she's uncertain, he's self-assured. He has a gift for stealth—he'll sneak up in silence and wait patiently for pets. Hari is a gifted athlete, and though he's blind, he excels in running with the team. Once, when the dogs got caught in a whiteout blizzard, he found the trail by smell and led us all to safety.

LITTER THEME: Beans; named for haricots vert

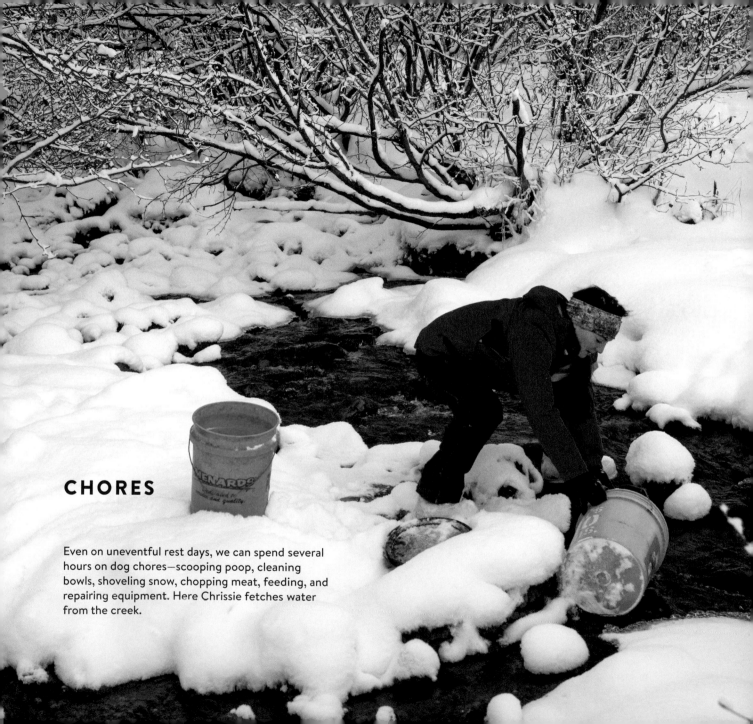

CHORES

Even on uneventful rest days, we can spend several hours on dog chores—scooping poop, cleaning bowls, shoveling snow, chopping meat, feeding, and repairing equipment. Here Chrissie fetches water from the creek.

Donut gets her toenails checked.

Our meatorade recipes are a trade secret.

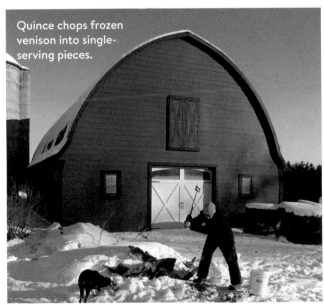

Quince chops frozen venison into single-serving pieces.

Oh, you were planning on scooping poop? Why don't you give me a belly rub instead?

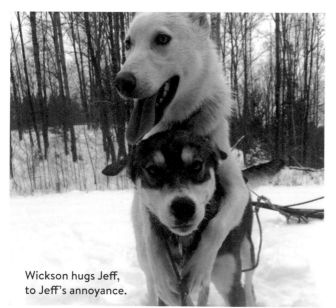

Wickson hugs Jeff,
to Jeff's annoyance.

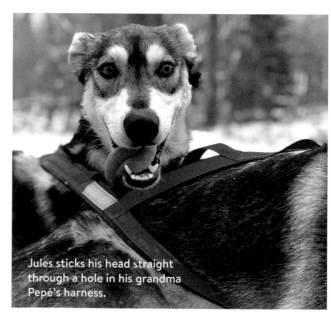

Jules sticks his head straight
through a hole in his grandma
Pepé's harness.

YEARLINGS

Puppies and tweenage pups go on short fun runs, but none of our dogs start real training until they're at least a year old, when their bodies have had time to develop. That means that in the winter, we often have young dogs who are running with the team for the first time—and who are in the peak of their goofy, awkward, obsessed-with-everything phase.

Teaching a young sled dog to pull is almost ridiculously easy. You put a harness on them, clip them to the towline with the rest of the team, and go. Within about five steps, they've got it—and they're ecstatic. You can see them make the connection, see them finally understand that this energy they were born with is meant for something, meant for *this*, and now they're doing it, and it belongs to them forever. Their running is jubilant. It's natural. It's the easiest thing in the world.

Everything around the running? Not so much.

Harnesses are weird, booties are awkward, and tuglines aren't intuitive. And running with a partner is great, but what if your partner doesn't appreciate it when you step on their head? It doesn't take long for young dogs to get the hang of things, but until they do, everything is extra exciting.

HANDLERS

A handler is a skilled assistant who helps with a dog team. They might live with a team for years, working closely with the dogs, or volunteer on a short-term basis, like at a single race. A lot of mushers got their start as handlers; it's a way to work with sled dogs without the commitment (and expense) of owning your own team, and ideally with a mentor to help you learn.

We've had three long-term handlers over the years—people who started as friends, but have become something closer to family. There are no people we'd rather be stuck in the wilderness with, and few whose company and wisdom we're more grateful for.

Sarah Marshall came to our team through the writing world, and she's become a fast friend of the dogs. She bonds instantly with even the wildest yearlings.

Chrissie Bodznick and Blair met a decade ago, when they were both working as nature guides in Colorado, and Chrissie has spent three winters with the team. She's a talented musher and photographer and can write songs on the spot for every occasion.

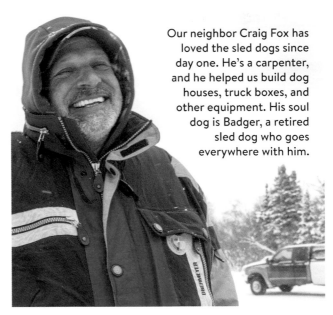

Our neighbor Craig Fox has loved the sled dogs since day one. He's a carpenter, and he helped us build dog houses, truck boxes, and other equipment. His soul dog is Badger, a retired sled dog who goes everywhere with him.

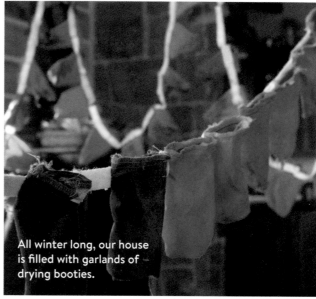

All winter long, our house is filled with garlands of drying booties.

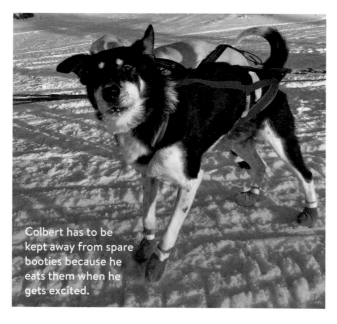

Colbert has to be kept away from spare booties because he eats them when he gets excited.

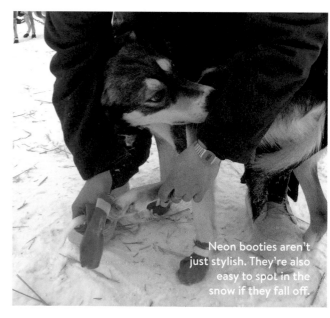

Neon booties aren't just stylish. They're also easy to spot in the snow if they fall off.

BOOTIES

A sled dog bootie is simple: one layer of fabric with a Velcro strap on top. Its purpose isn't to keep a dog's paws warm, but to prevent snow and ice from clumping between their toes.

The calculus of when to run with booties, and when to run without them, is more art than science. It depends on temperature, snow texture, distance, and— more than anything else—a musher's knowledge of their own dogs' needs. Some dogs have tough feet, and hardly need booties at all, while others have sensitive paws and run best with protection. On warm winter days, when we skip booties, we rub wax on the dogs' paws to keep snow from sticking.

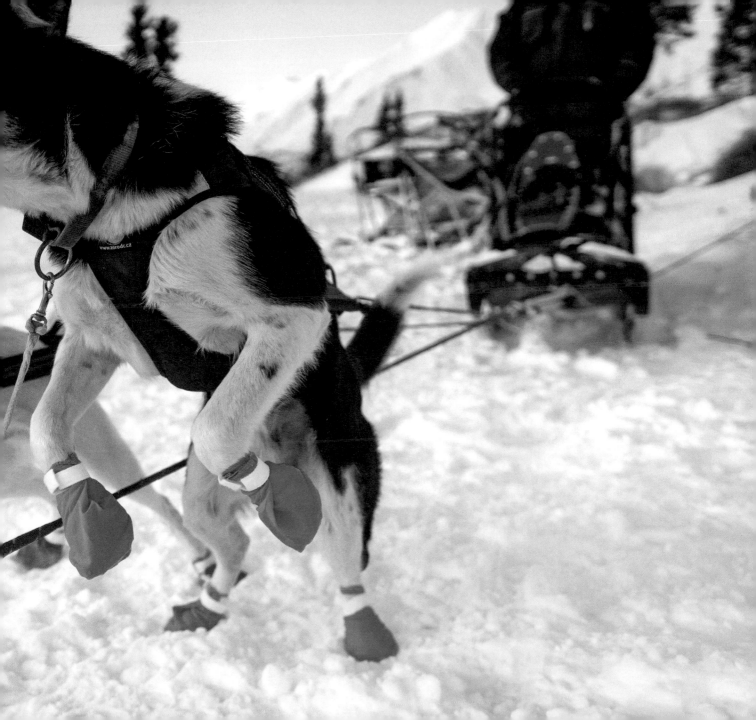

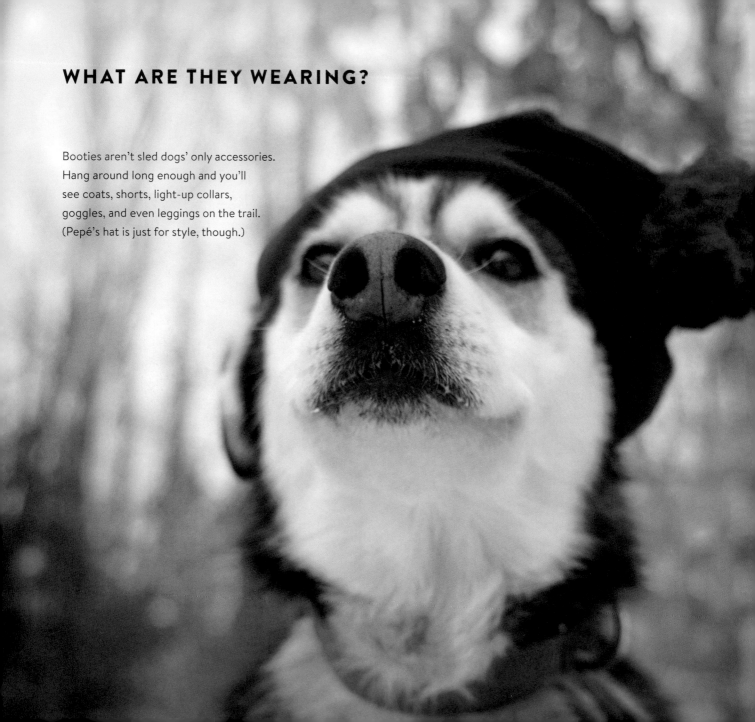

WHAT ARE THEY WEARING?

Booties aren't sled dogs' only accessories.
Hang around long enough and you'll
see coats, shorts, light-up collars,
goggles, and even leggings on the trail.
(Pepé's hat is just for style, though.)

The team gets fitted for jackets. A well-sized jacket stays in place while the dogs are running, but provides enough coverage for naps in the straw, too.

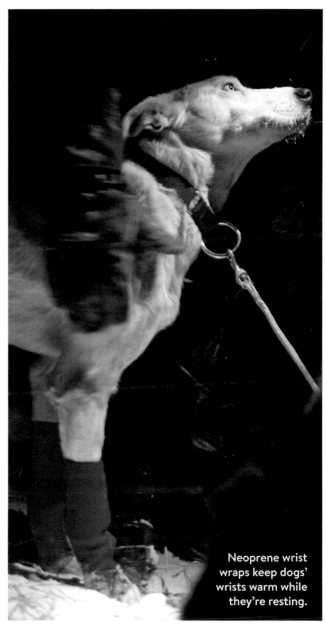

Neoprene wrist wraps keep dogs' wrists warm while they're resting.

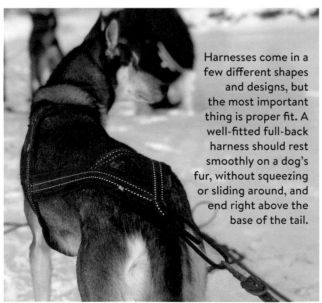

Harnesses come in a few different shapes and designs, but the most important thing is proper fit. A well-fitted full-back harness should rest smoothly on a dog's fur, without squeezing or sliding around, and end right above the base of the tail.

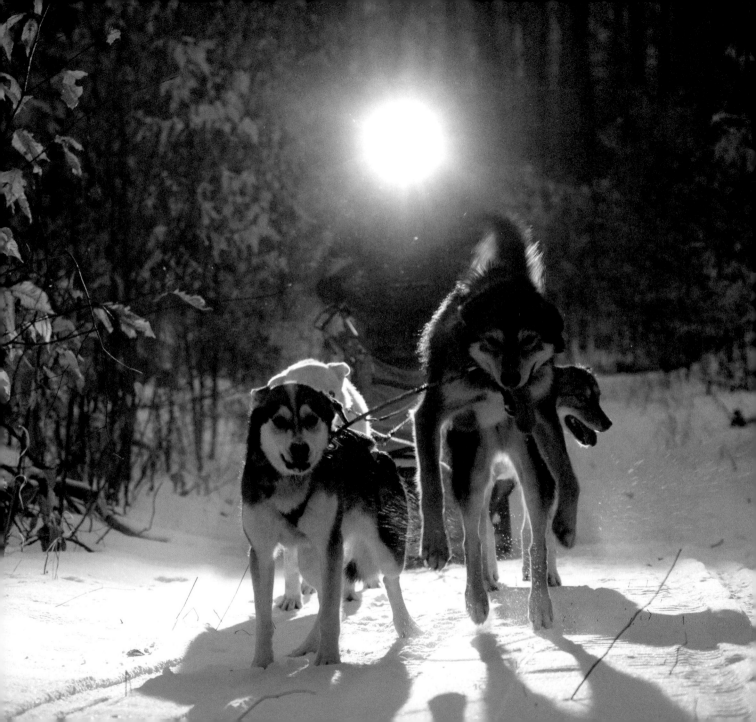

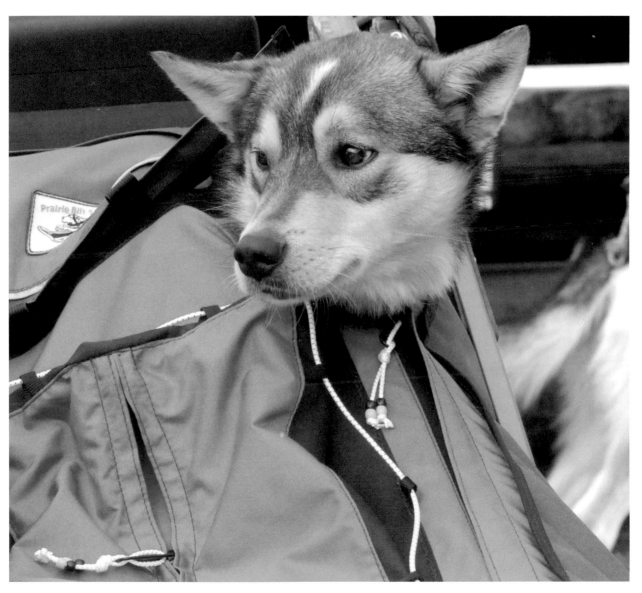

If a dog gets tired or needs a break on a run, they can ride in the sled bag, which accommodates human and canine passengers alike.

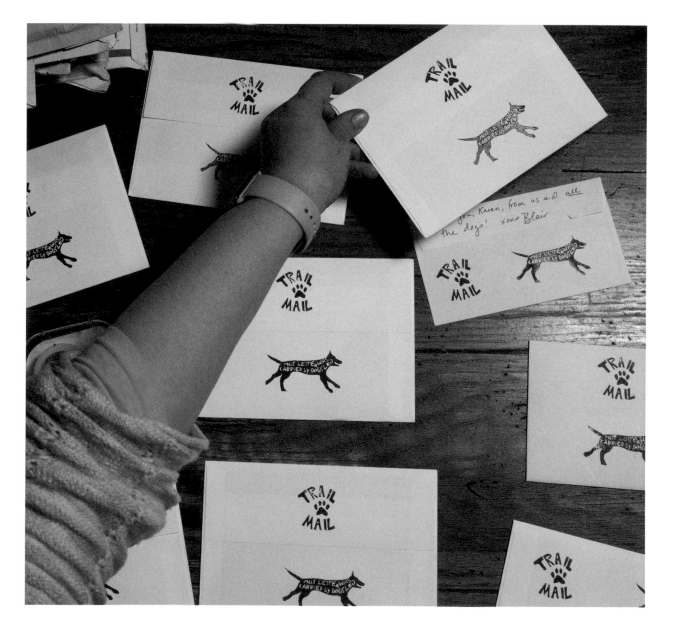

TRAIL MAIL

When we wanted a way to thank fans of the team and honor the sport's history, it only seemed natural to use the mail. Every winter, people send us boxes of holiday cards from around the world, and we give each letter a dogsled ride before sending it on its way. The first year we carried almost five hundred letters from strangers; by the third, we carried over four thousand. Stamping the letters takes time, and mushers and friends come together to help. While we're stamping, we like to imagine kids—in Texas, in Poland, in New York City—checking the mail, finding a card from a loved one that was *carried by sled dogs*, and getting a little burst of adventure in their day.

CLOSE ENCOUNTERS

It's not uncommon for dog teams to encounter wild animals. After all, we're sharing the trail with wolves, coyotes, deer, bear, porcupine, grouse, caribou, and many other species—or, more accurately, they're sharing the trail with us. Sometimes wolves and coyotes follow us for miles, or even a few days, perhaps enjoying the meat crumbs the dogs leave behind from their snacks. The dogs like the company. They raise their heads and smell the wind.

One animal we prefer to avoid is moose. Moose have been known to attack dog teams and mushers, probably because of their instincts about wolves. Dogs, on the other hand, think moose are enormous meals just popping out of snowbanks on their long legs. We've passed many moose, mostly from a distance, and our close encounters have been peaceful. (We give them the right of way.) If we're lucky, the only moose troubles we'll encounter in a given winter are the deep, tube-like stompholes they leave in the trail.

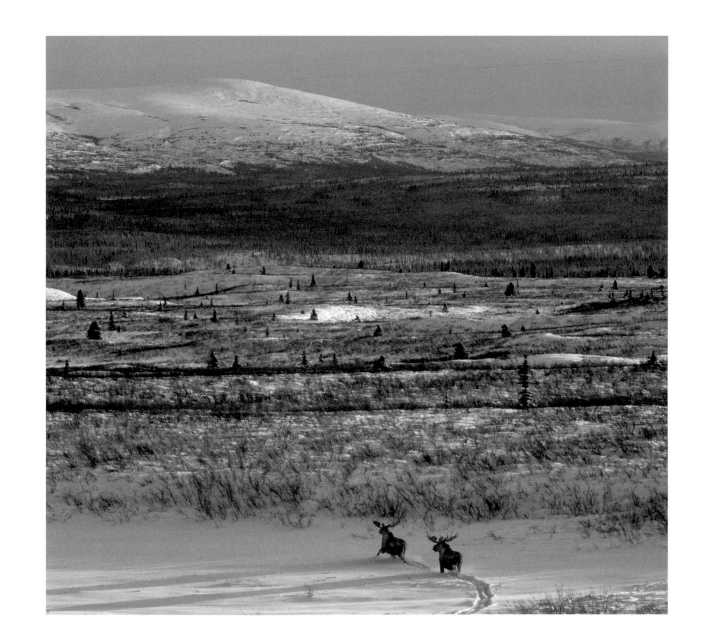

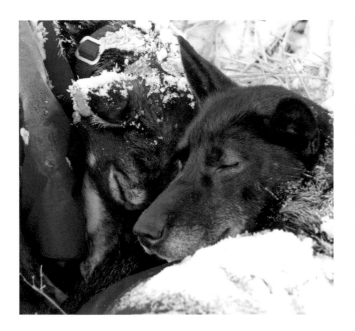

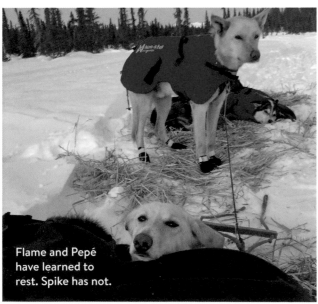

Flame and Pepé
have learned to
rest. Spike has not.

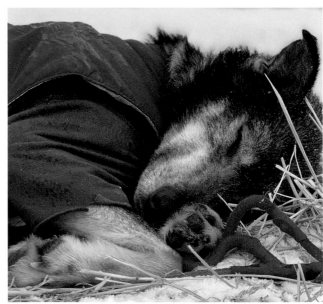

LEARNING TO REST

Though it seems counterintuitive, training isn't just about building endurance. It's just as important to learn to rest. And for sled dogs, learning to rest is a heckuva lot harder than learning to run.

We practice by taking the team for a run, then camping along the trail. The dogs learn that straw beds and blankets mean it's time to take a nap, even if they don't feel tired yet. They know that soon enough they'll get to run again.

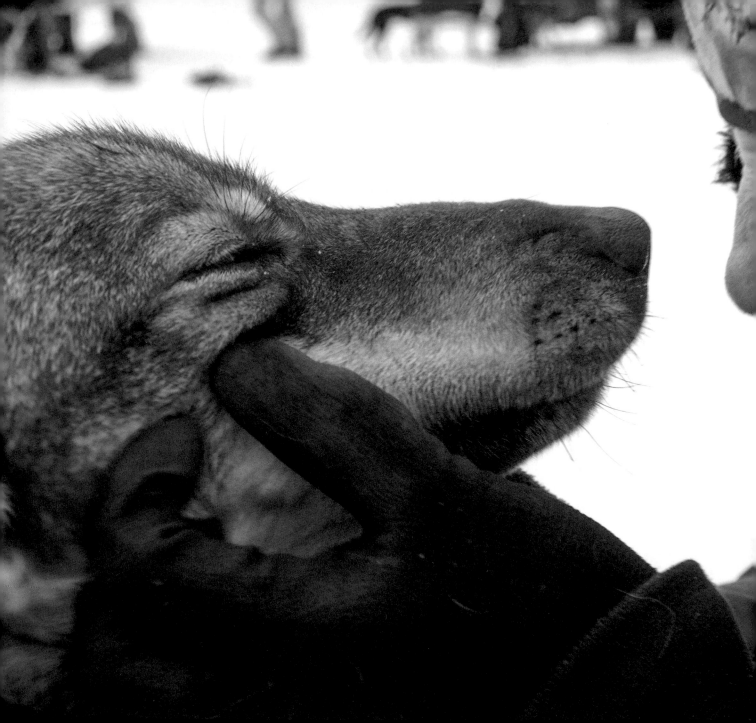

WHY RACE?

We worked with sled dogs for years before thinking about racing. The way Blair saw it, if the best part of mushing was the solitude, the chance to share something beautiful and intimate with your dogs, then why turn it into a competition? Why drive somewhere far away and make it about how *fast* you could mush, rather than the experiences you had along the way? And if the dogs were already perfect (they were), then why bother with something resembling evaluation?

But when we went to our first race, we got it.

The race was like a sled dog party—teams running together, a beautiful groomed trail, safe road crossings, people and dogs reuniting. There are races that start in the woods with a handful of people, just insiders, and there are races that start in the middle of towns and cities, the streets lined with spectators, and at core they're all about celebrating the dogs and the sport we all love.

Plus, a race is the safest way to travel any serious distance by dog team. If we want to take a four-hundred-mile camping trip with the dogs, we have to plot a route, make sure it's accessible, worry about road crossings and trail blockages, figure out how we'll contact a vet if need be, and carry hundreds of pounds of food. But if we enter a four-hundred-mile race, all those needs are accounted for. There are checkpoints, resupplies, veterinarians, volunteers at road crossings, and a whole system for helping anyone who gets in trouble. All of that's in place *so that we can have our adventure.* And we've learned more from vets and other experts at checkpoints, hands-on lessons about rest and massage and nutrition, than any amount of reading could have taught us.

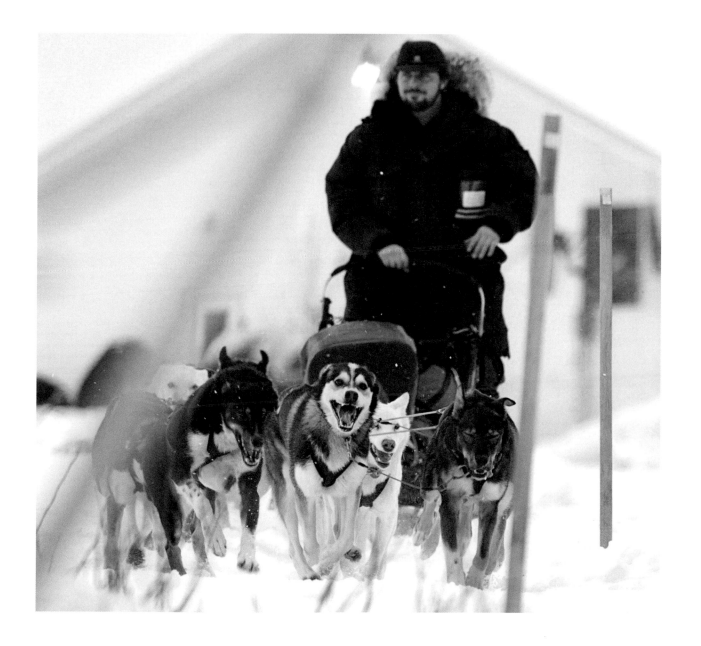

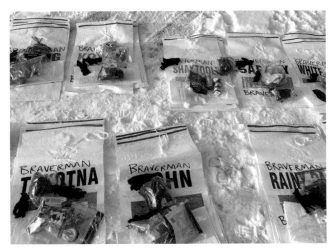

Sorting equipment. Since it's usually below freezing, and drop bags stay outside, we don't worry about meat thawing. But if we think the weather might warm up, we pack the meat in freezer bags for extra insulation.

Different runner plastics work best for different temperatures and conditions, and they get scratched up with use, so we always carry spares.

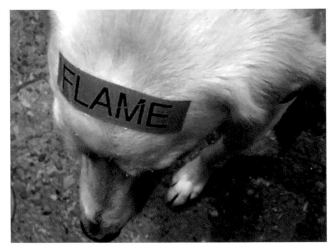

When fans of the dogs sponsor us with particular items, we print their names on labels and apply them to the items so we can think of our sponsors when we use them. Quince loves the label-maker. Sometimes he gets carried away.

Volunteers organize a musher's bags for Iditarod. Each bag is limited to fifty pounds, and they're sealed with specially marked zip tags to prevent tampering.

DROP BAGS

One major pre-race task is packing drop bags, which get sent ahead to checkpoints for resupply. For a race with five checkpoints, a musher might pack ten to fifteen drop bags, with five hundred pounds of supplies—mostly meat.

A typical bag might contain two kinds of beef, frozen and sliced into strips; sliced salmon; raw chicken thighs; chicken skin; raw bacon; and two kinds of kibble (a high-nutrient performance kibble and a generic "junk food kibble" that we mix in as a treat).

We also pack spare booties, paw ointments, sled runner plastics, dry socks and gloves, batteries, and human food—typically something in a sealed pouch that we can drop into the dog-food cooker to thaw. And of course cheesecake, which is our go-to trail snack because it's easy to eat frozen.

RACE DAY

Mushers usually don't get much sleep the night before a race, but it's our job to keep the dogs well-rested. We get to the staging area early, feed the team a light but hydrating meal, and put them back in the truck to nap until the race itself begins.

We finalize our equipment—choosing the right sled runners for the snow conditions, packing the sled with essential gear, and double-checking *everything*. No matter how many hours we have, this time always passes in a flash. Before we know it, it's time to harness the dogs and head for the starting chute.

What comes next is chaos. Dogs jumping and barking, volunteers running, sled brake tips scraping packed snow, and spectators cheering. At the starting line, volunteers hold back the sled while the dogs leap in place, eager and impatient. Mushers have one or two minutes to jog up, give their dogs words of encouragement, and dive back onto the shuddering sled before the countdown ends. Three . . . two . . . one . . . the sled is released . . .

And suddenly it's quiet.

The transition is startling every time. The sled starts moving; the world slides into place. It doesn't matter how big the crowd is, whether people are yelling, if you're in the middle of a city street. It's just you and your dogs.

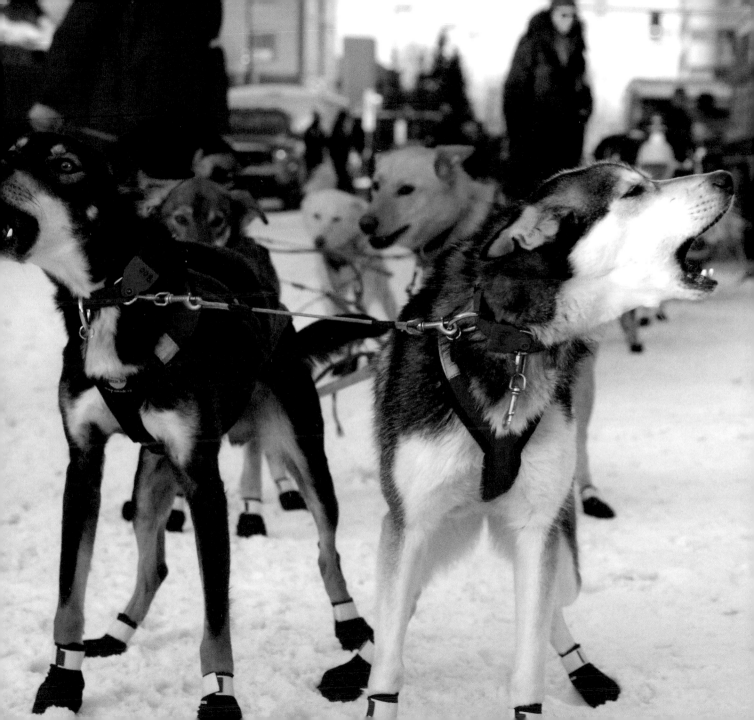

It can be hard to gauge temperature in unfamiliar conditions, so we keep a thermometer on the sled. That way we know we're using the right runners. When it comes to the dogs' temperatures, though, we don't go by number but by observation. If they seem chilly, they get coats; if they're warm, we slow down.

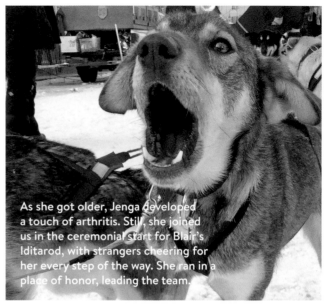

As she got older, Jenga developed a touch of arthritis. Still, she joined us in the ceremonial start for Blair's Iditarod, with strangers cheering for her every step of the way. She ran in a place of honor, leading the team.

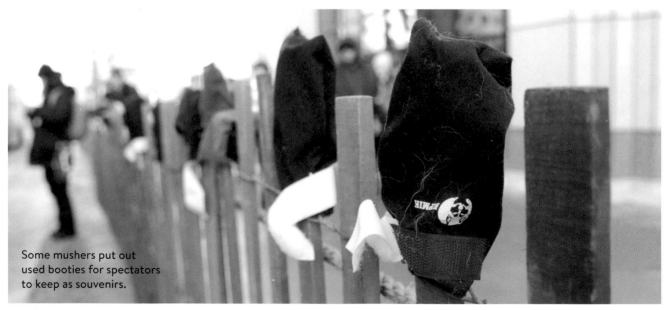

Some mushers put out used booties for spectators to keep as souvenirs.

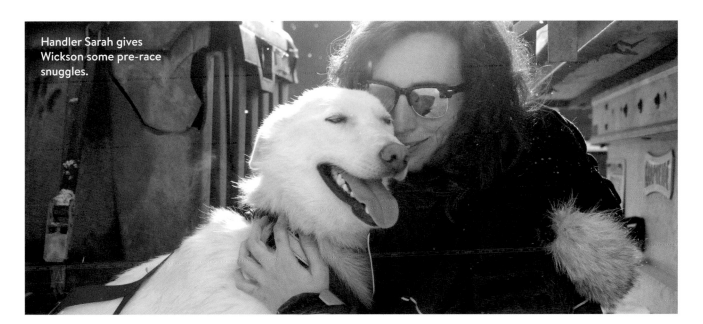

Handler Sarah gives Wickson some pre-race snuggles.

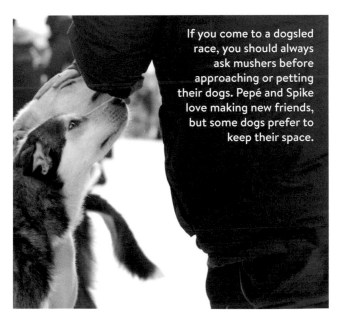

If you come to a dogsled race, you should always ask mushers before approaching or petting their dogs. Pepé and Spike love making new friends, but some dogs prefer to keep their space.

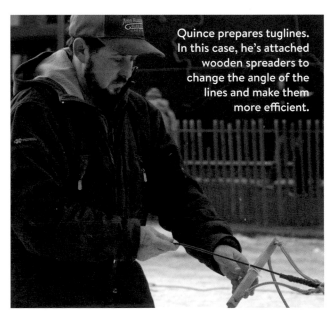

Quince prepares tuglines. In this case, he's attached wooden spreaders to change the angle of the lines and make them more efficient.

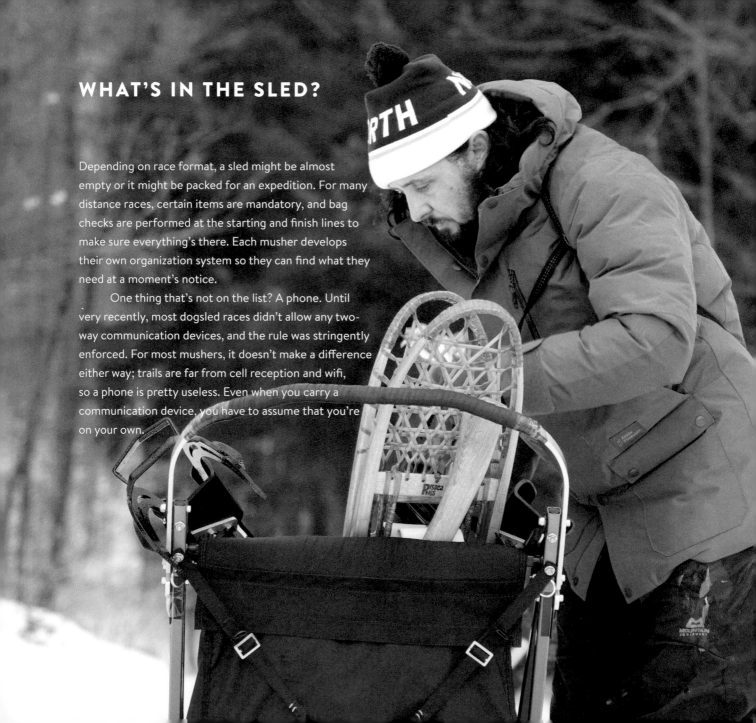

WHAT'S IN THE SLED?

Depending on race format, a sled might be almost empty or it might be packed for an expedition. For many distance races, certain items are mandatory, and bag checks are performed at the starting and finish lines to make sure everything's there. Each musher develops their own organization system so they can find what they need at a moment's notice.

One thing that's not on the list? A phone. Until very recently, most dogsled races didn't allow any two-way communication devices, and the rule was stringently enforced. For most mushers, it doesn't make a difference either way; trails are far from cell reception and wifi, so a phone is pretty useless. Even when you carry a communication device, you have to assume that you're on your own.

A DISTANCE SLED USUALLY CARRIES THE FOLLOWING REQUIRED GEAR:

- Dog food (meals, plus an extra 1 lb./dog)
- People food
- A cooker to melt snow
- Fuel for the cooker
- Fire-starters
- A compass
- An extreme-weather sleeping bag
- Spare dog booties
- A knife
- An ax
- A cable cutter
- A cooler (to keep dog food thawed)
- Snowshoes
- Dog jackets
- A race-issued SPOT device to track location by satellite
- Two headlamps
- Dog bowls
- First aid kit for dogs and humans
- A veterinary book, used to track the dogs' weights, appetites, and any issues that come up. The dogs get physical exams at most checkpoints, and records make it easy for vets to tell if something's changed.

THIS GEAR ISN'T REQUIRED, BUT MOST MUSHERS CARRY IT ANYWAY:

- Towline parts
- Spare runner plastics
- A change of socks and long underwear in a waterproof bag
- A ladle
- Dog shirts
- Neoprene wrist wraps
- Blankets
- A ski pole to help push the sled
- Multi-tool for sled repairs
- Extra bedding for dogs (straw or foam pads)
- A Thermos to keep drinks from freezing
- Charcoal hand and foot warmers
- iPod or MP3 player
- Sleeping pad
- Spare headlamp batteries
- Tarp
- Rain gear and/or waders
- Ice cleats
- Rope
- Charger for batteries

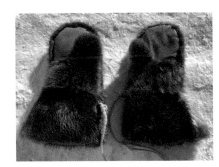

The dogs have built-in cold-weather adaptations, but a musher's are external. Blair sewed these mittens with fur from a beaver that our dogs ate. They're lined with two layers of fleece and a half-inch of Primaloft.

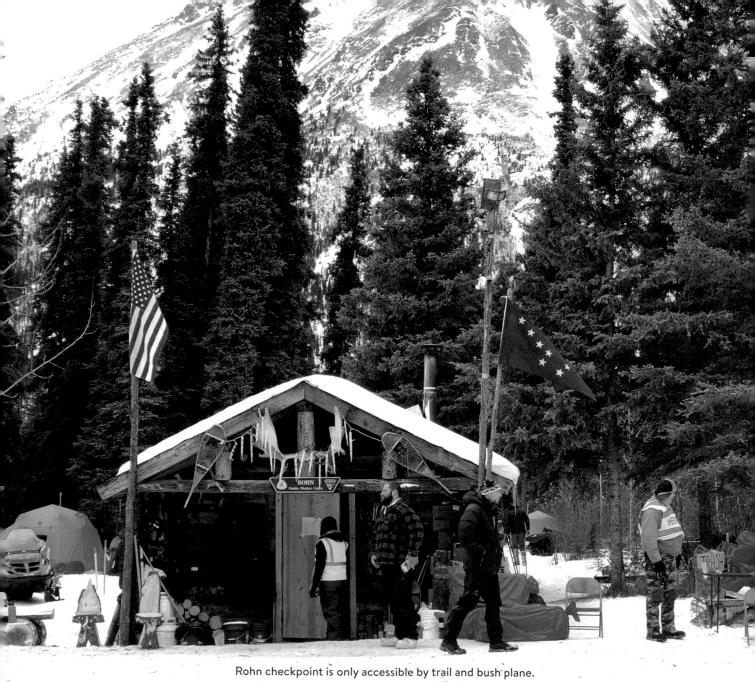
Rohn checkpoint is only accessible by trail and bush plane.

CHECKPOINTS

Checkpoints are spots along the race trail where teams can rest and resupply. They typically offer straw and cooker fuel, plus a chance to pick up drop bags, and there's always a vet on call to answer questions and check on the dogs.

Amenities vary. Checkpoints can be in churches, lodges, gravel pits, airplane hangars, bars, riverbeds—anywhere with space for dog teams to sleep. Hardy volunteers stay up all night to welcome the teams.

It's a luxury to reach a checkpoint that has a dry place for mushers to sleep inside. The Upper Peninsula 200 is an assisted race, with checkpoints in community centers, which means that handlers can help take care of dogs while mushers rest up in the library. Here Blair stretches after a nap.

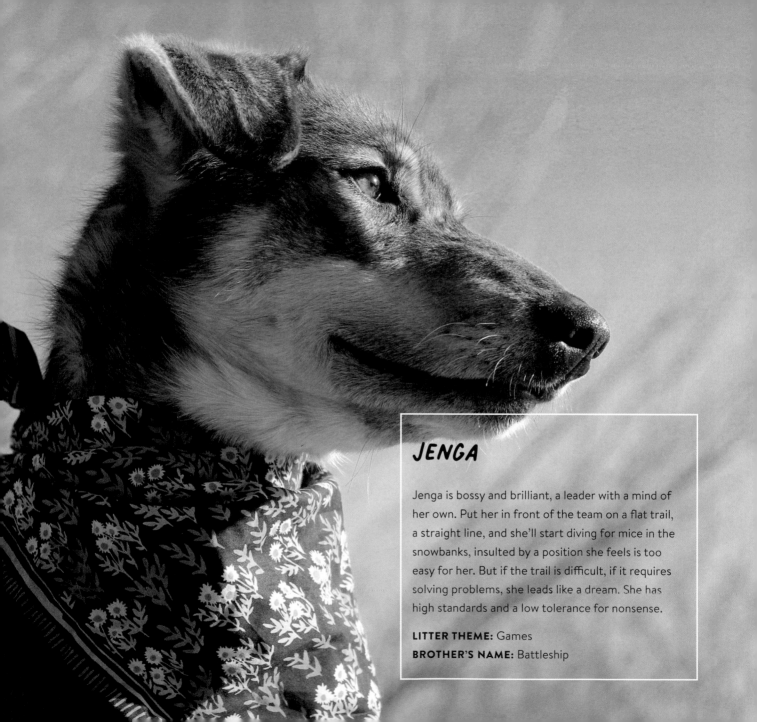

JENGA

Jenga is bossy and brilliant, a leader with a mind of her own. Put her in front of the team on a flat trail, a straight line, and she'll start diving for mice in the snowbanks, insulted by a position she feels is too easy for her. But if the trail is difficult, if it requires solving problems, she leads like a dream. She has high standards and a low tolerance for nonsense.

LITTER THEME: Games
BROTHER'S NAME: Battleship

WHATEVER

JUST WASH YOUR HANDS
(AND NO TP IN THE TOILET!)

We like Elim's style.

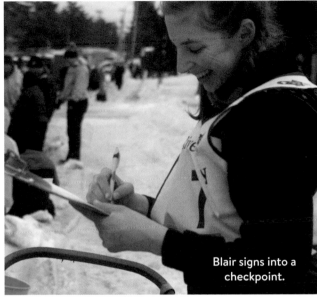

Blair signs into a checkpoint.

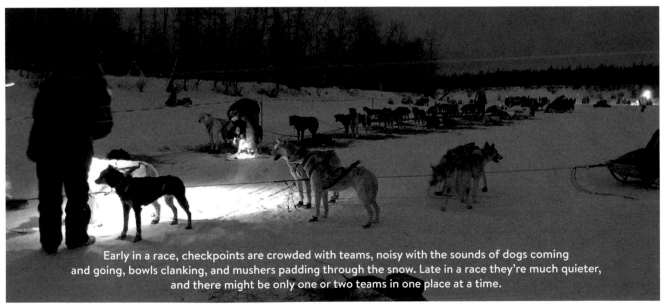

Early in a race, checkpoints are crowded with teams, noisy with the sounds of dogs coming and going, bowls clanking, and mushers padding through the snow. Late in a race they're much quieter, and there might be only one or two teams in one place at a time.

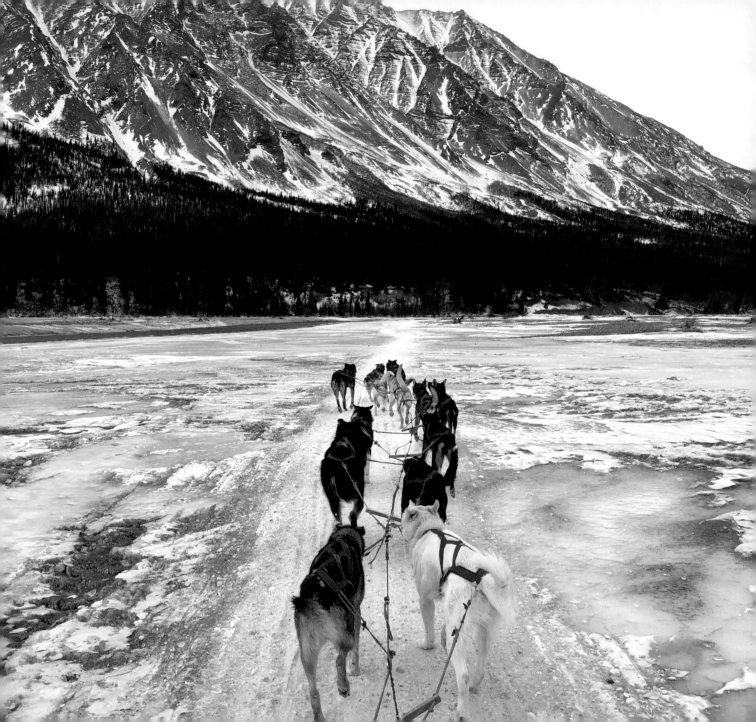

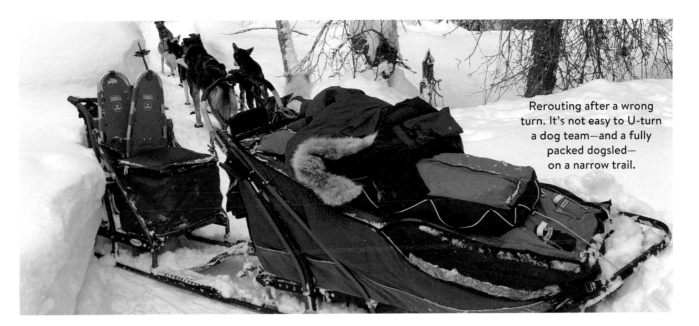

Rerouting after a wrong turn. It's not easy to U-turn a dog team—and a fully packed dogsled—on a narrow trail.

In areas without much snow, the tips of the sled brake fill with grass.

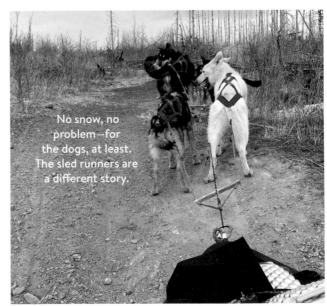

No snow, no problem—for the dogs, at least. The sled runners are a different story.

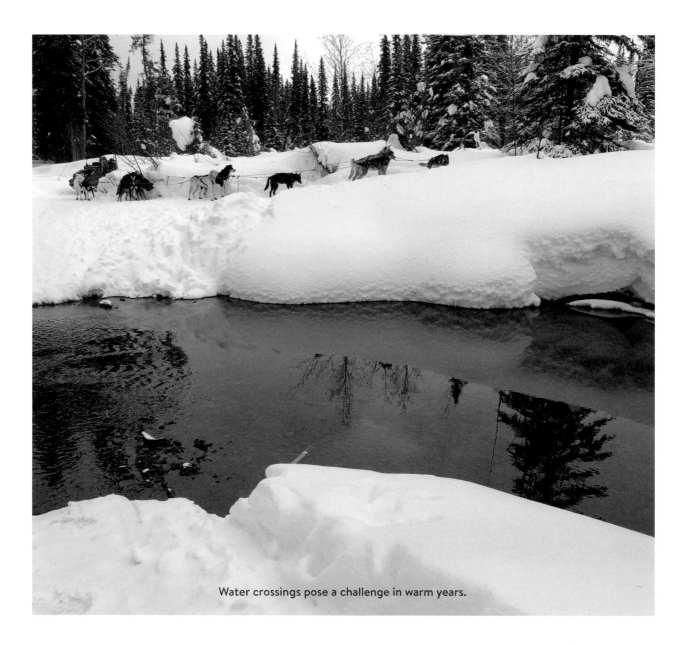

Water crossings pose a challenge in warm years.

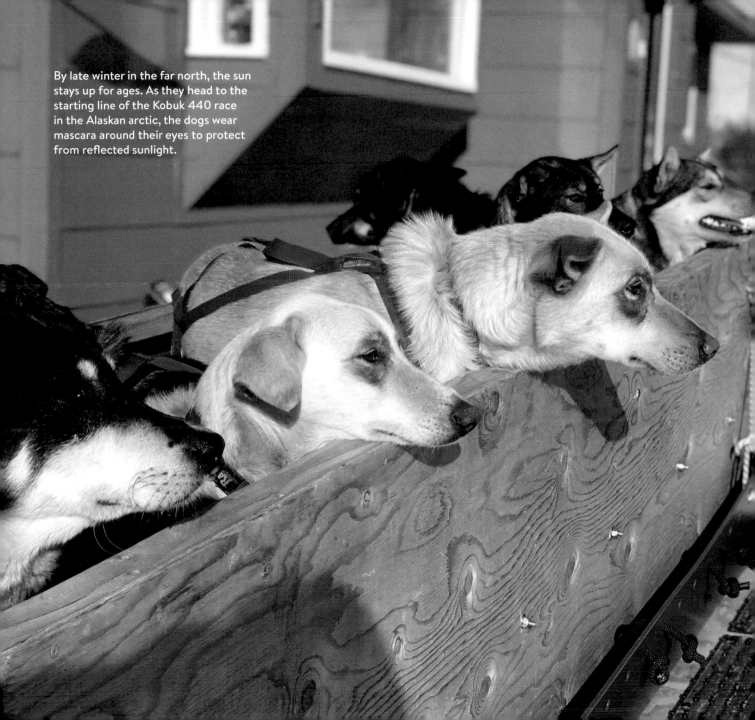

By late winter in the far north, the sun stays up for ages. As they head to the starting line of the Kobuk 440 race in the Alaskan arctic, the dogs wear mascara around their eyes to protect from reflected sunlight.

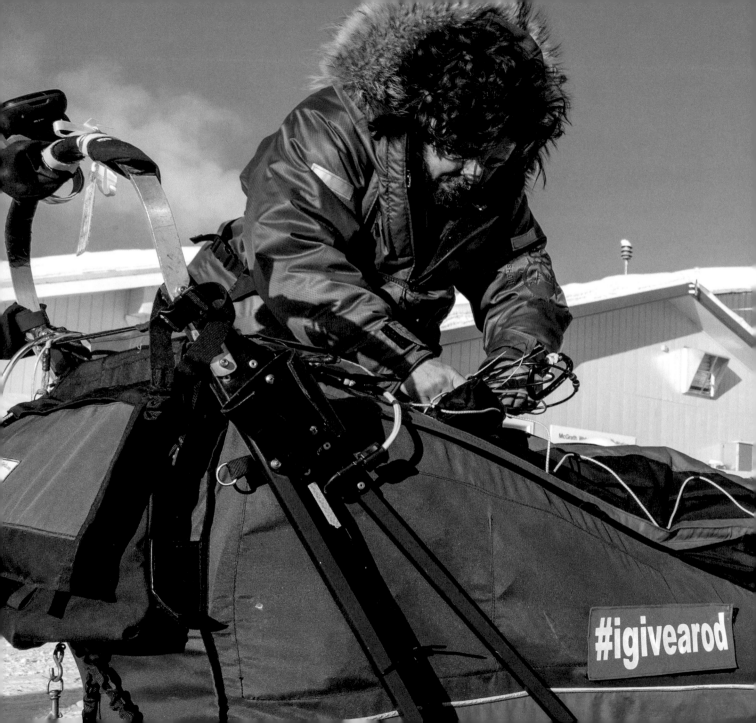

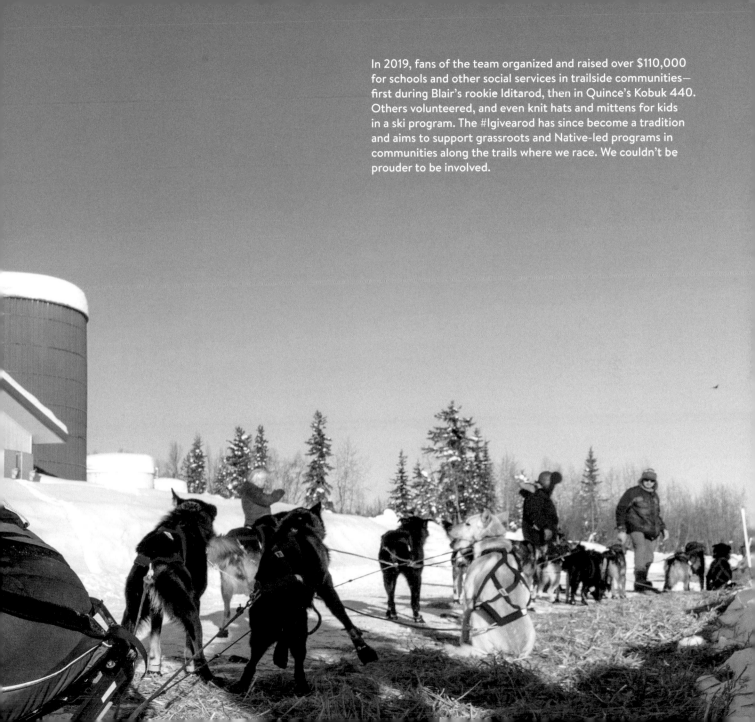

In 2019, fans of the team organized and raised over $110,000 for schools and other social services in trailside communities— first during Blair's rookie Iditarod, then in Quince's Kobuk 440. Others volunteered, and even knit hats and mittens for kids in a ski program. The #Igivearod has since become a tradition and aims to support grassroots and Native-led programs in communities along the trails where we race. We couldn't be prouder to be involved.

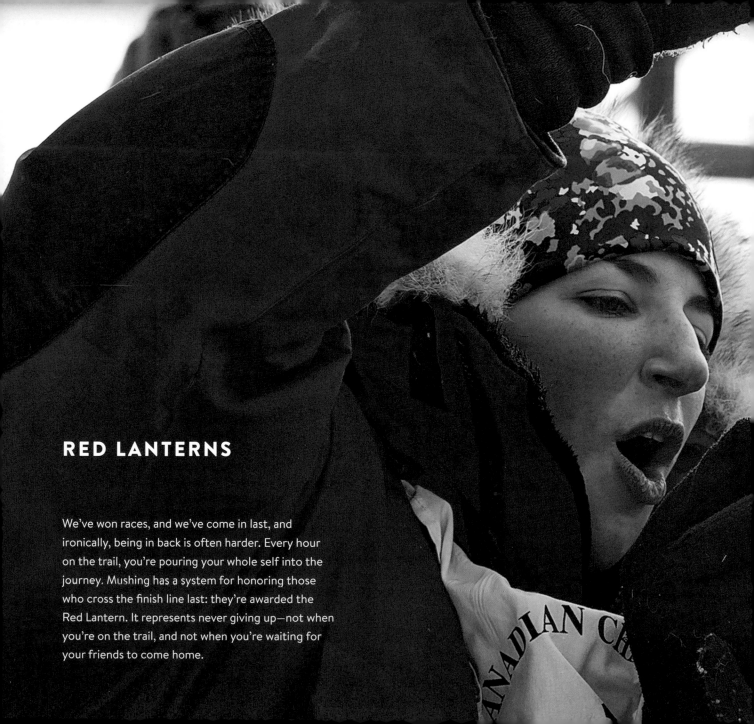

RED LANTERNS

We've won races, and we've come in last, and ironically, being in back is often harder. Every hour on the trail, you're pouring your whole self into the journey. Mushing has a system for honoring those who cross the finish line last: they're awarded the Red Lantern. It represents never giving up—not when you're on the trail, and not when you're waiting for your friends to come home.

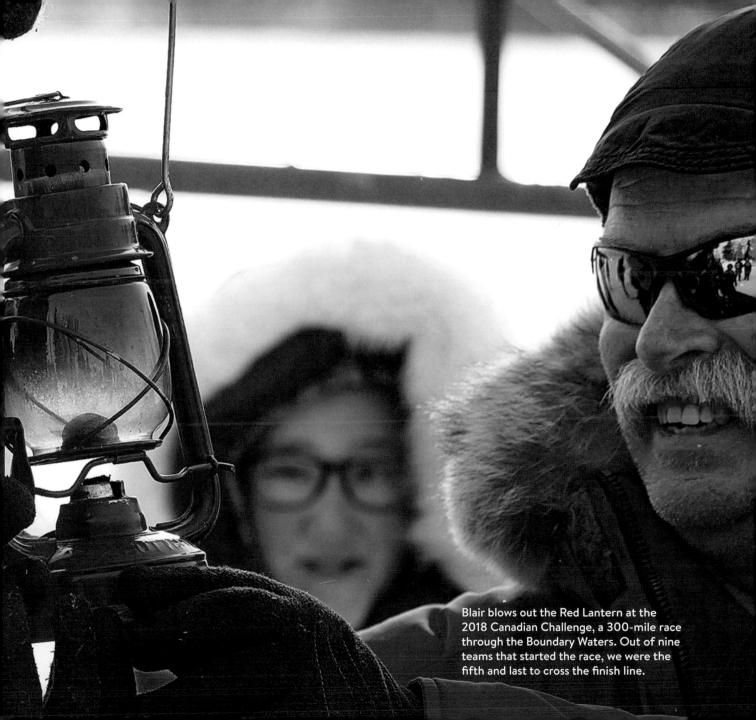

Blair blows out the Red Lantern at the 2018 Canadian Challenge, a 300-mile race through the Boundary Waters. Out of nine teams that started the race, we were the fifth and last to cross the finish line.

MUD SEASON

MUD SEASON

Here in Wisconsin, we have winter and we have summer. In between, we have mud.

Mud season is exactly what it sounds like. The snow melts, the ground thaws, and everything is ugly. We might be able to find a few miles of snow-crusted trail in the shady woods if we really look for it, but the snow is too coarse and spotty for sledding. We can't use carts or the ATV because we'd sink into the muck. Still, the dogs think mud season is fantastic.

That's because all winter long, they bury caches of meat in the snow—and then they forget about them. These hidden meals stay frozen and hidden from November to April. Then the air warms up, everything starts dripping, and like manna rising from the depths of hell, all of this disgusting, delicious food is revealed at once.

It doesn't matter how quickly we clean up the meat; the dogs are always quicker. For days they're in bliss. They are too full to do anything but wander to the next stinking pile and engulf it. They eat, they roll, they sniff each other, and they enjoy the biggest dog party you ever did see.

Just when it seems like the mud will last forever, tips of grass start to emerge. We've made it to the next stage of spring, the stage when each day brings thickening leaves, songbirds, and butterflies. But it's always striking, that in-between time. In a way, we're grateful: it's a reminder, through the dogs, to enjoy the things you put away for later—especially before someone else eats them.

Pepé likes her dead things with teeth.

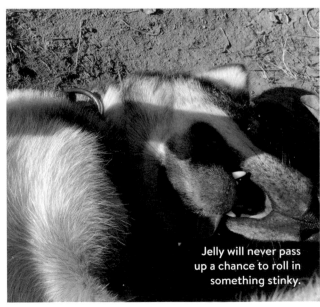

Jelly will never pass up a chance to roll in something stinky.

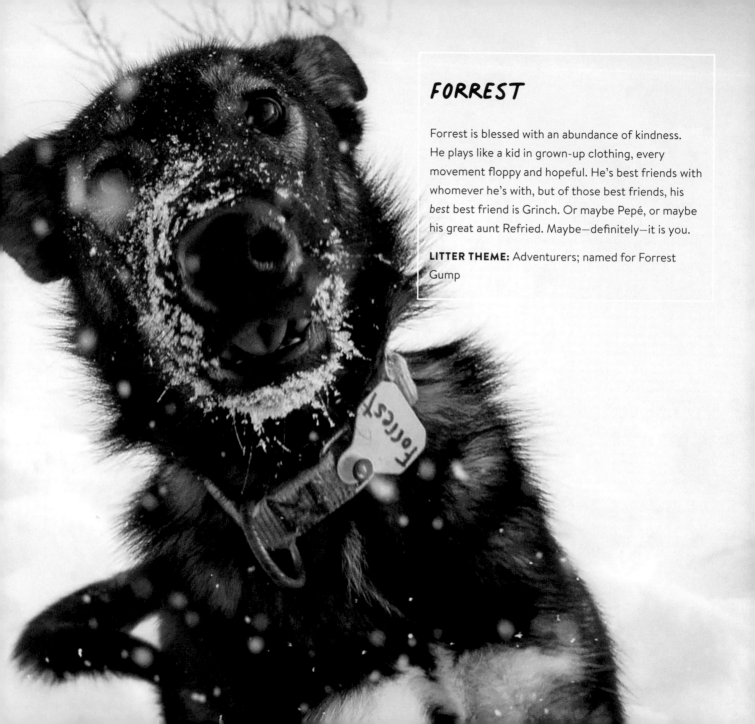

FORREST

Forrest is blessed with an abundance of kindness. He plays like a kid in grown-up clothing, every movement floppy and hopeful. He's best friends with whomever he's with, but of those best friends, his *best* best friend is Grinch. Or maybe Pepé, or maybe his great aunt Refried. Maybe—definitely—it is you.

LITTER THEME: Adventurers; named for Forrest Gump

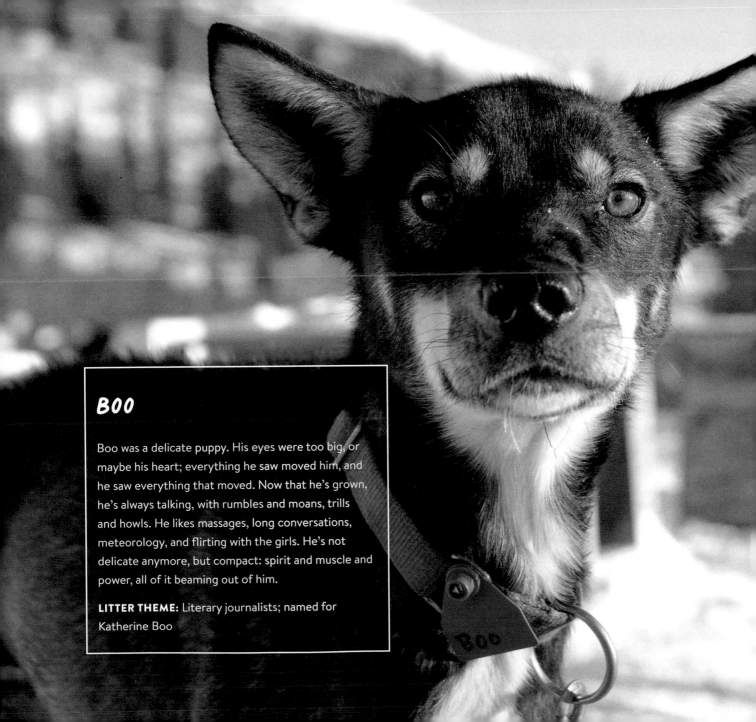

BOO

Boo was a delicate puppy. His eyes were too big, or maybe his heart; everything he saw moved him, and he saw everything that moved. Now that he's grown, he's always talking, with rumbles and moans, trills and howls. He likes massages, long conversations, meteorology, and flirting with the girls. He's not delicate anymore, but compact: spirit and muscle and power, all of it beaming out of him.

LITTER THEME: Literary journalists; named for Katherine Boo

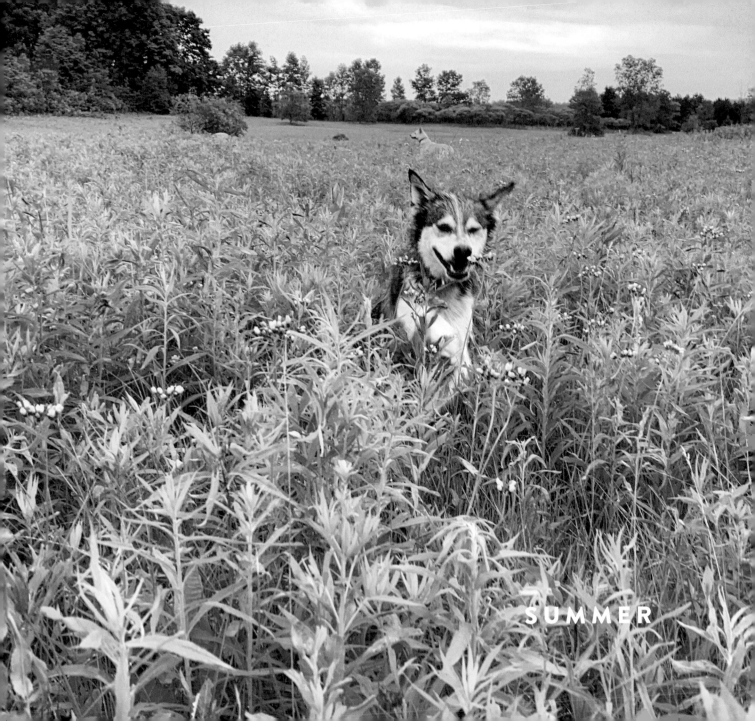

SUMMER

SUMMER

Summer is our annual reset, a chance to rest before ramping up again a few months later. For the dogs, summer is an adventure all its own.

It's usually too warm for the dogs to run in harness, so we're always looking for fun ways to keep them entertained. We get to be creative, and we get to do things with the dogs that we don't have time to do much in winter—like bringing them to obedience classes, working with them one-on-one, and (our personal favorite) general romping in the forest. The dogs get new toys, though toys never last long, and our playpens are filled with happy blurs.

Winter is our favorite season, but we love summer because it's so different. And we think the dogs do, too.

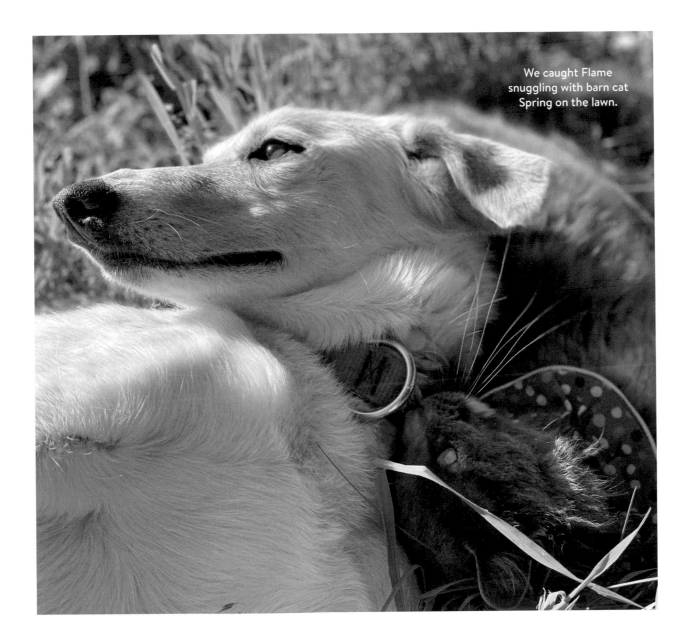

We caught Flame snuggling with barn cat Spring on the lawn.

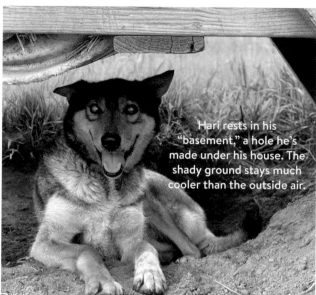

Hari rests in his "basement," a hole he's made under his house. The shady ground stays much cooler than the outside air.

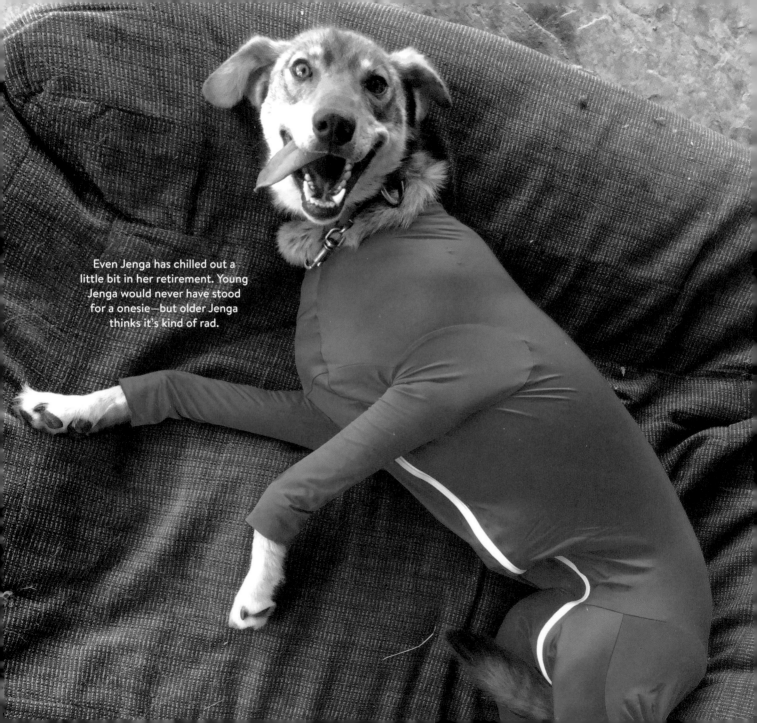

Even Jenga has chilled out a little bit in her retirement. Young Jenga would never have stood for a onesie—but older Jenga thinks it's kind of rad.

RETIREMENT

Sled dogs retire when they choose, and they make their choice clear, usually between ages seven and eleven. When a dog becomes less *overwhelmingly ecstatic* about training, or if they're more tired than their teammates at the end of a run, we take it as a sign that they're ready to take a step back.

Our retirees still love fun runs, though, so we do the canine equivalent of sending the kids to grandma's house: we run them with puppies. Both groups go shorter distances than the main team—the puppies because they're easing up, and the old dogs because they're easing down. But most importantly, the puppies are chaos, and the old dogs are used to chaos. You put the wildest puppy next to the calmest senior and by the end of a five-mile jaunt, the puppy will have soaked in a little calm and the senior will have an extra bounce in his step. The elders teach the pups how to run, and the pups remind the retirees how to play.

Some of our dogs retire to pet homes, too, which can be a great fit for the right person or family. After a brief period of adjustment, and with plenty of daily exercise, retired sled dogs are usually all too happy to nap on the couch or in front of the fire.

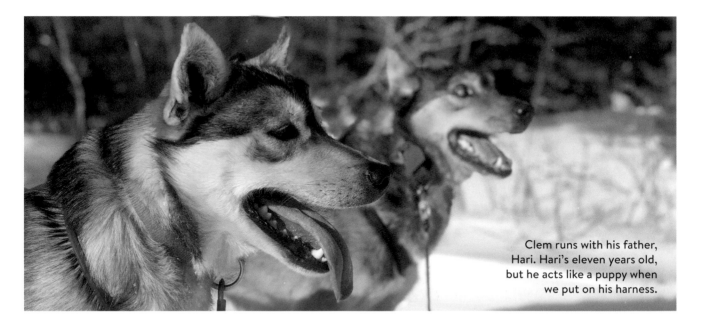

Clem runs with his father, Hari. Hari's eleven years old, but he acts like a puppy when we put on his harness.

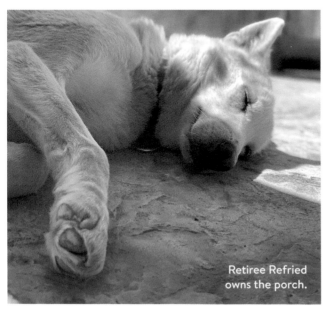

Retiree Refried owns the porch.

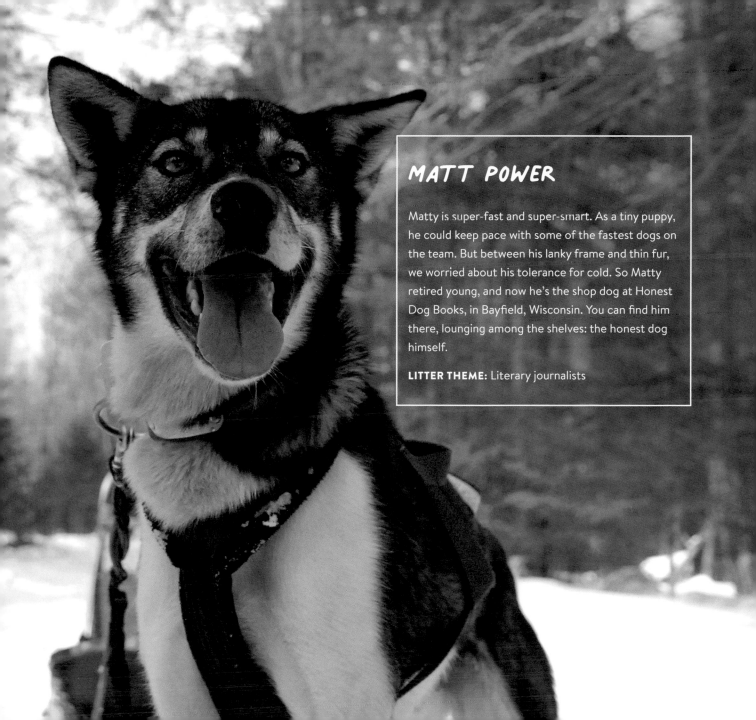

MATT POWER

Matty is super-fast and super-smart. As a tiny puppy, he could keep pace with some of the fastest dogs on the team. But between his lanky frame and thin fur, we worried about his tolerance for cold. So Matty retired young, and now he's the shop dog at Honest Dog Books, in Bayfield, Wisconsin. You can find him there, lounging among the shelves: the honest dog himself.

LITTER THEME: Literary journalists

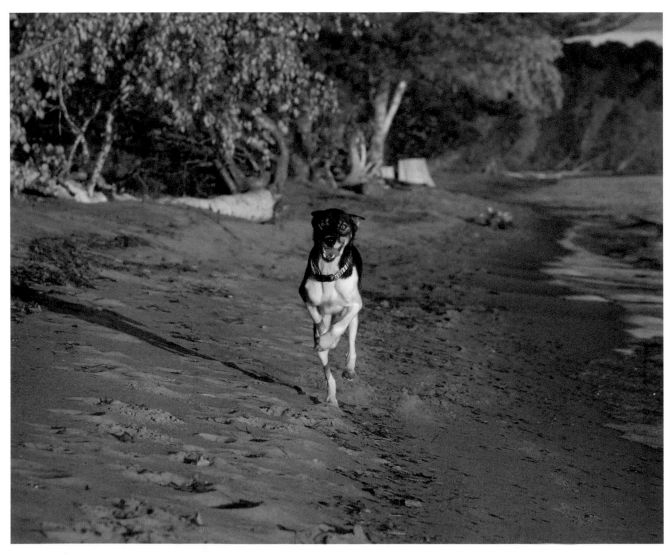

We used to think it would be impossibly difficult to part with dogs when they retire to other homes. But what's surprised us is how joyful it is, too. When dogs move on from our team, it's not because they don't have a home here but because there's somewhere else, a team or family, that's a better fit for what they need. It's because they're going somewhere they'll thrive even more. And when we watch them from a distance—running with a team that's just their speed, splashing around on beaches, bonding with a family who loves them more than anything—there's little that could make us more proud.

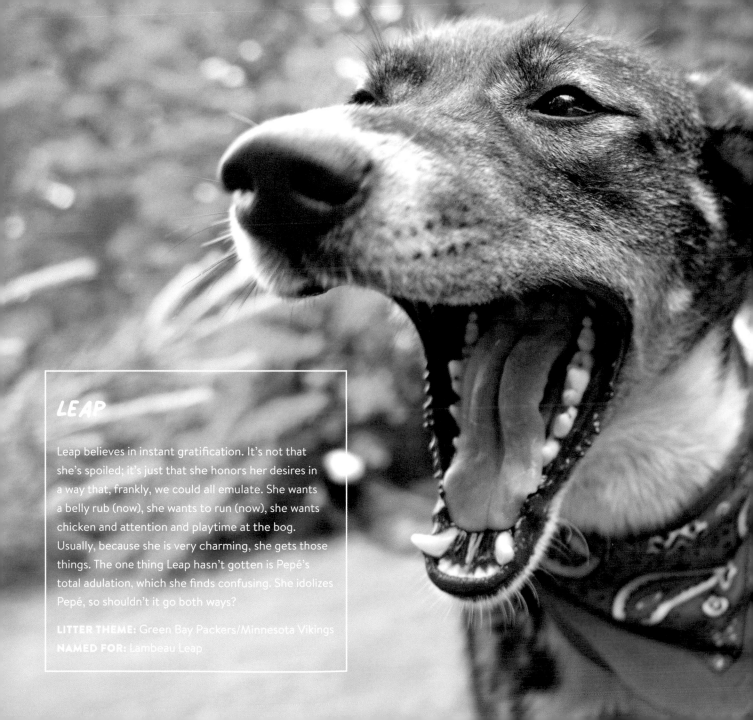

LEAP

Leap believes in instant gratification. It's not that she's spoiled; it's just that she honors her desires in a way that, frankly, we could all emulate. She wants a belly rub (now), she wants to run (now), she wants chicken and attention and playtime at the bog. Usually, because she is very charming, she gets those things. The one thing Leap hasn't gotten is Pepé's total adulation, which she finds confusing. She idolizes Pepé, so shouldn't it go both ways?

LITTER THEME: Green Bay Packers/Minnesota Vikings
NAMED FOR: Lambeau Leap

PUPPIES

And then there are puppies.

Summer is often puppy season, and though we don't have puppies every year—we plan litters for when older dogs are retiring, so the team stays roughly the same size—we can't think of green grass and hot afternoons, kiddie pools and butterflies, without thinking about the puppies who love them.

Alaskan huskies grow up fast. By the time they're a few weeks old, they're explorers—chewing everything they can, making friends, taking it all in. Boulders are mountains, logs are tightropes, and every leaf on the breeze is a mystery. We take them to the cranberry bog, where the ground bounces under their paws. We introduce them to their elders, their grandparents, who play like puppies themselves.

And we bring them on journeys—to friends' houses to socialize, and to nursing homes, where residents tell us stories of their own good dogs. The pups taste fish and bear for the first time. They eat flowers. They fall into creeks, climb out, shake, and jump right in again.

Sometimes the world is too much, and that's okay, too. There's no rush to learn everything. If the pups are tired, they can lounge in the shade, their warm bellies rising and falling. When they sleep, they rest their chins on each other's backs.

You are sled dogs, we tell them, and you have teamwork and courage and magic in your blood.

But we think they already know.

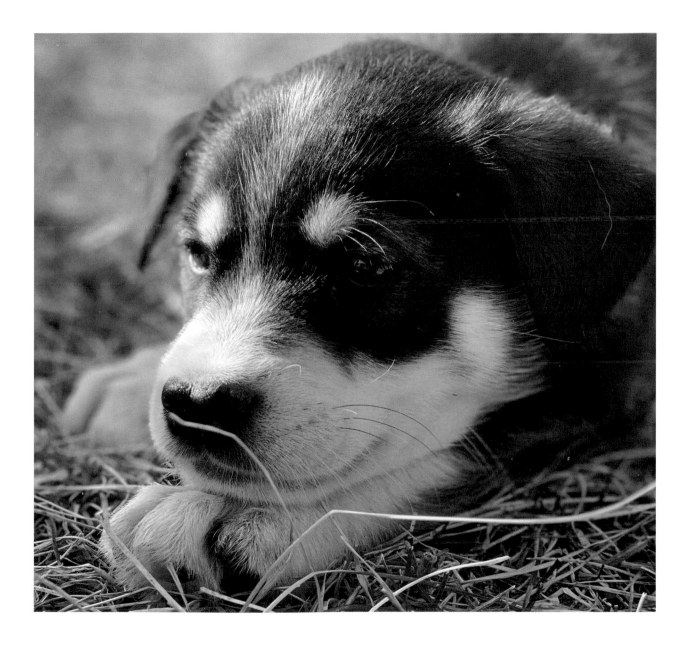

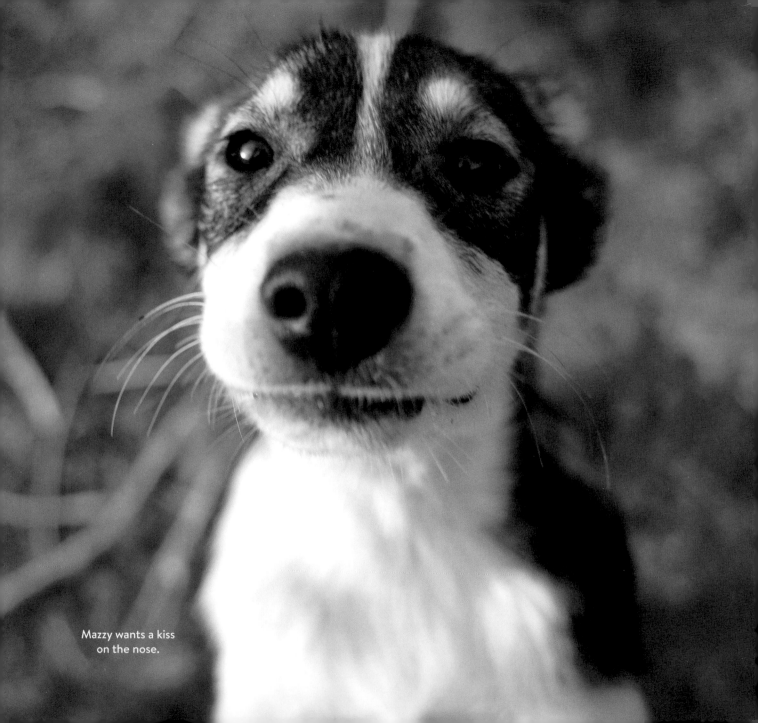

Mazzy wants a kiss
on the nose.

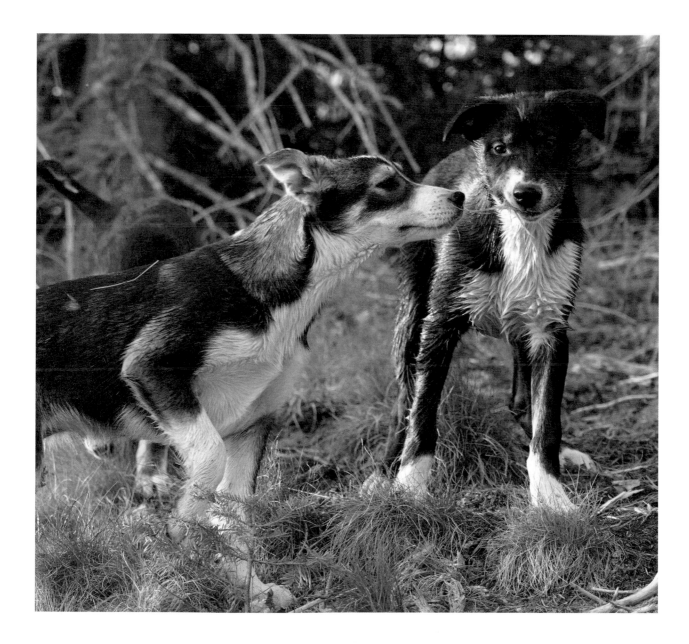

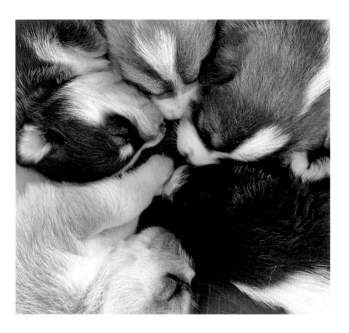
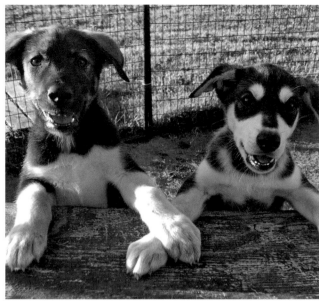

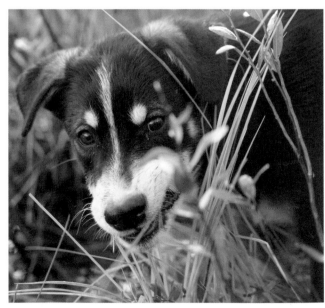

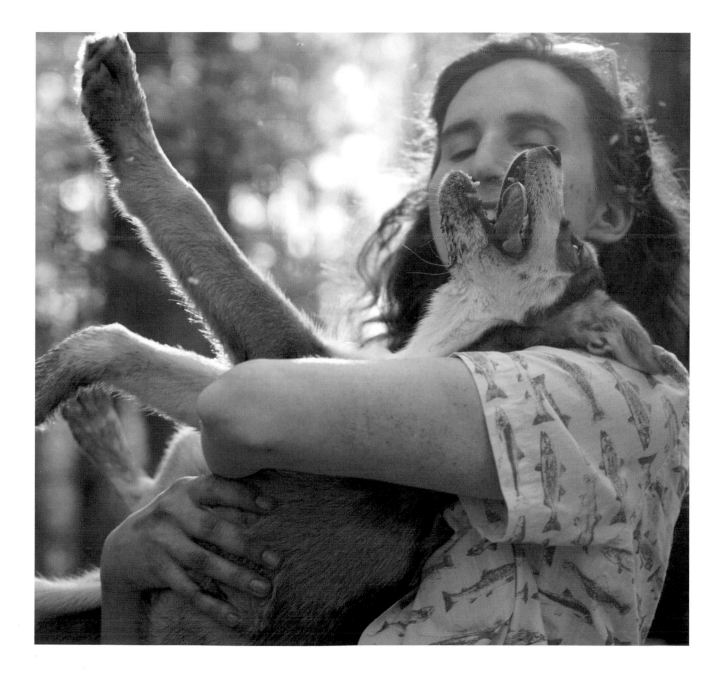

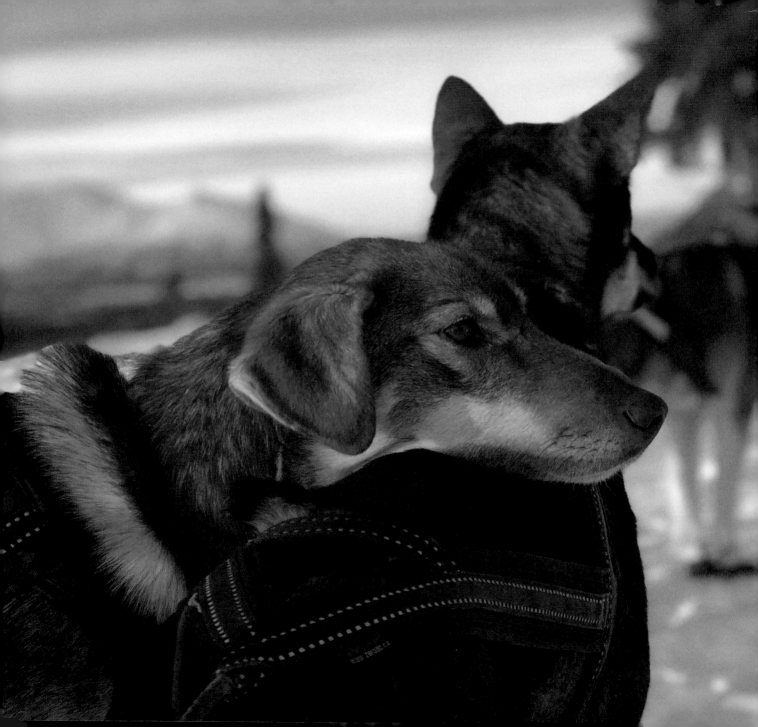

ACKNOWLEDGMENTS

The degree to which our dog team is also a human team—a collective labor of joy—cannot be overstated; it's one of our greatest honors to be part of a community. A book, too, is a group effort, and this record of adventure would never happen without the people who made that adventure possible. We especially want to thank the talented photographers whose work appears on these pages. Chrissie Bodznick, who spent three winters with us, captures the dogs as their truest selves and is a big part of the team herself. Nathaniel Wilder presents the light and energy of mushing in ways we've rarely seen. A huge thank-you to Julie Buckles, Antonia Reitter, Keith Thornhill, Jeff Schultz, Meera Subramanian, Narayan Mahon, Jennifer Campbell-Smith, Ryan Redington, Danica Novgorodoff, Jim Williams, Lu Olkowski, and Katie Orlinsky. We're incredibly grateful for the chance to see the dogs through your eyes.

Editor Denise Oswald's vision made this book happen; agents Andy McNicol, Andrea Blatt, and Suzanne Gluck shepherded the project through.

Sara Birmingham guided the book with the skill of a great lead dog, and Norma Barksdale kept everything running smoothly. To the team at Ecco: Miriam Parker, Meghan Deans, Ashlyn Edwards, Caitlin Mulrooney-Lyski, Rachel Sargent, Allison Saltzman, Elizabeth Yaffe, and Renata de Oliveira—it's a privilege to be in your hands.

The team's internet community means the world to us, and has allowed us to be part of things far bigger than we could have imagined. Matthew Carruth, Kelly O'Hara, Tom "Duncan" Brady, MJ Bradley, Sasha, and the many other #uglydogs contributors to the highly leaderful #Igivearod effort (and to Kate and Lori for #Iknitarod): your work has given our dogs' steps even more purpose, and you've deepened our mission and relationships along the trail. Thank you so much to our Patreon sponsors, as well as Morgan Taxidermy, UpNorth Processing, Priefert, and TDS Weather. It's a good thing the dogs can't read, because we could never begin to thank them properly here—but we hope they feel the depth of our love every day.

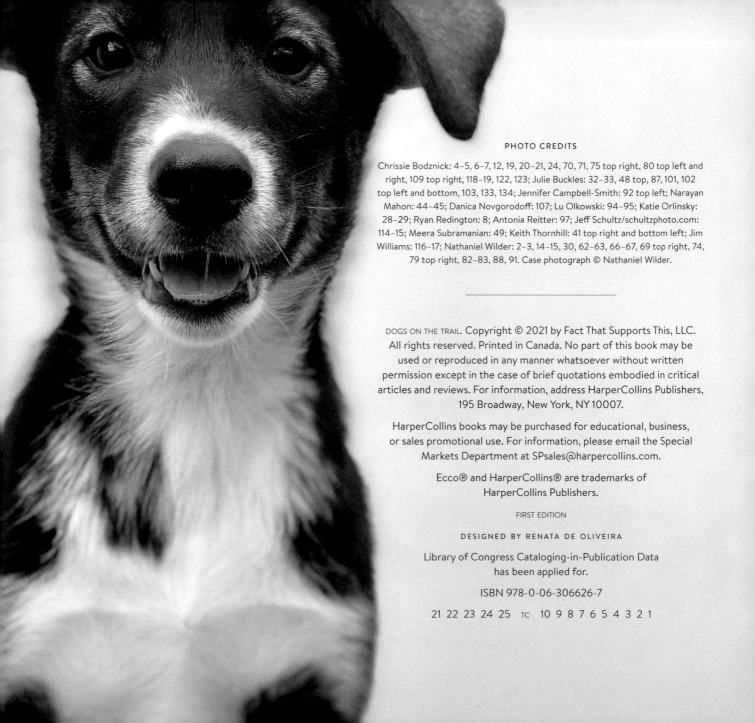

PHOTO CREDITS

Chrissie Bodznick: 4–5, 6–7, 12, 19, 20–21, 24, 70, 71, 75 top right, 80 top left and right, 109 top right, 118–19, 122, 123; Julie Buckles: 32–33, 48 top, 87, 101, 102 top left and bottom, 103, 133, 134; Jennifer Campbell-Smith: 92 top left; Narayan Mahon: 44–45; Danica Novgorodoff: 107; Lu Olkowski: 94–95; Katie Orlinsky: 28–29; Ryan Redington: 8; Antonia Reitter: 97; Jeff Schultz/schultzphoto.com: 114–15; Meera Subramanian: 49; Keith Thornhill: 41 top right and bottom left; Jim Williams: 116–17; Nathaniel Wilder: 2–3, 14–15, 30, 62–63, 66–67, 69 top right, 74, 79 top right, 82–83, 88, 91. Case photograph © Nathaniel Wilder.

DOGS ON THE TRAIL. Copyright © 2021 by Fact That Supports This, LLC. All rights reserved. Printed in Canada. No part of this book may be used or reproduced in any manner whatsoever without written permission except in the case of brief quotations embodied in critical articles and reviews. For information, address HarperCollins Publishers, 195 Broadway, New York, NY 10007.

HarperCollins books may be purchased for educational, business, or sales promotional use. For information, please email the Special Markets Department at SPsales@harpercollins.com.

Ecco® and HarperCollins® are trademarks of HarperCollins Publishers.

FIRST EDITION

DESIGNED BY RENATA DE OLIVEIRA

Library of Congress Cataloging-in-Publication Data has been applied for.

ISBN 978-0-06-306626-7

21 22 23 24 25 TC 10 9 8 7 6 5 4 3 2 1